COURBET

G. Courbet

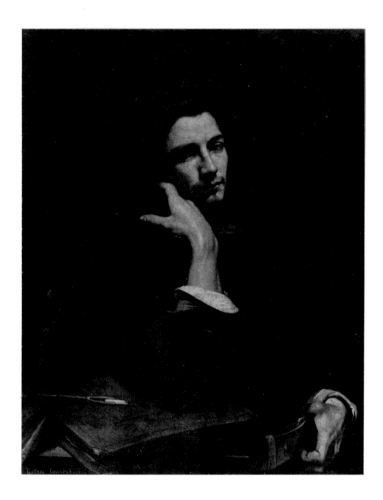

by Bruno Foucart

CROWN PUBLISHERS, INC. - NEW YORK

Title Page: THE MAN WITH THE LEATHER BELT
PORTRAIT OF THE ARTIST, between 1844–1849
Oil on canvas, 39⅜″ × 32¼″ (100 × 82 cm.)
Louvre Museum, Paris

Translated from the French by:
ALICE SACHS

Collection published under the direction of:
MADELEINE LEDIVELEC-GLOECKNER

Library of Congress Cataloging in Publication Data
Foucart, Bruno.
 G. Courbet.
 Bibliography: p. 94–95

 1. Courbet, Gustave, 1819–1877.
ND553.C9F6813 759.4 77–17224
ISBN O–517–53285–9

PRINTED IN ITALY – INDUSTRIE GRAFICHE CATTANEO S.P.A., BERGAMO – © 1977 BY BONFINI PRESS S.A., NAEFELS, SWITZERLAND
ALL RIGHTS IN THE U.S.A. ARE RESERVED BY CROWN PUBLISHERS INC., NEW YORK, N.Y.

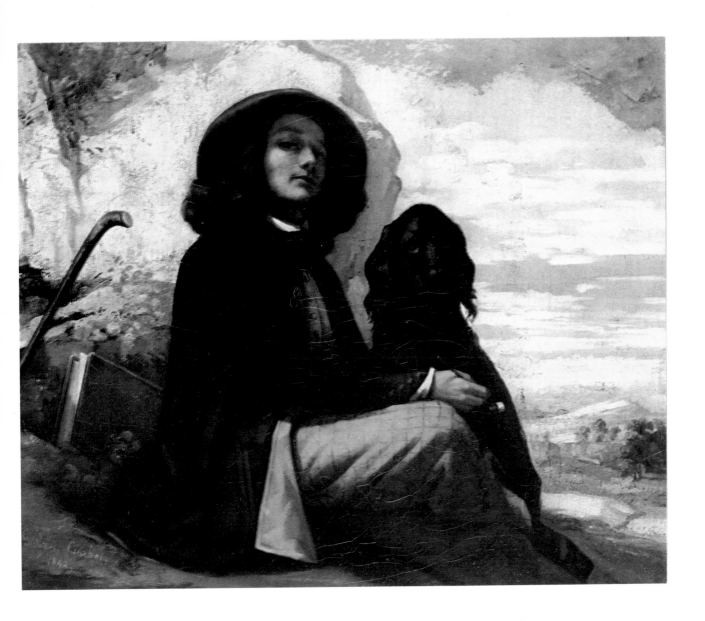

SELF-PORTRAIT WITH BLACK DOG, dated 1842. Salon of 1844, painted between 1842–1844?
Oil on canvas, 18¹/₈″ × 22¹/₁₆″ (46 × 56 cm.) Museum of the Petit-Palais, Paris

THE MAN AND THE MYTH

In the end the personality did great harm to the painter. Courbet, who toppled the column in the Place Vendôme, proclaimed his talent for and against everyone — the public, the administration, the critics — shunted aside the Ingres-Delacroix duo in order to give the entire space between the champions of color and of line drawing to Realism, acted as a catalyst to bring about a pictorial revival and fresh inventiveness in nineteenth century art and managed to become one of the most important figures in Parisian society, the favorite subject of caricaturists. Advancing his career with an unparalleled sense of publicity and public relations, making his faults seem eccentricities, obtaining personal advantage from

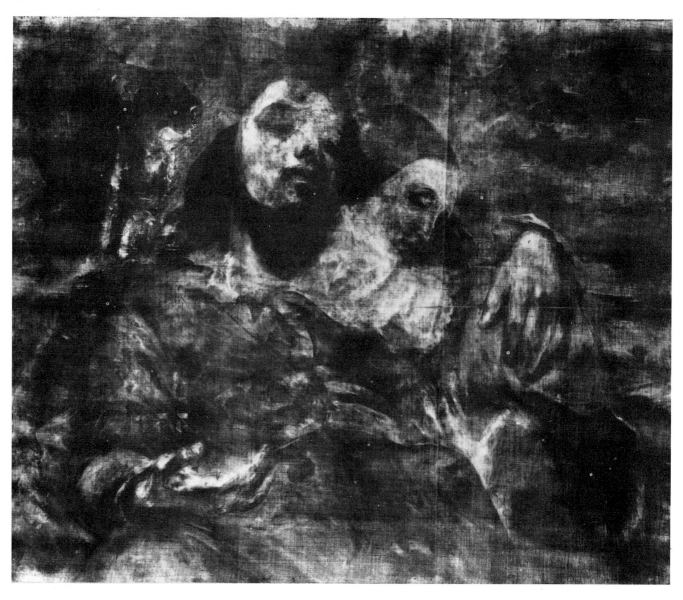

Wounded Man. X-ray photograph revealing a first composition on the theme of the «Siesta» (see pp. 10 and 29). (Published in the «Annales du Laboratoire de Recherches des Musées de France», Paris, 1973)

opposition and awarding dunce caps to those who defied him, he gave to the painter the status of a star and, making allowance for circumstances, heralded the advent of a Dali and a César. Yet this celebrity was not contrived or artificial. From the first it was apparent that Courbet was the best (or one of the best) painters of the period. His detractors regretted his failings but acknowledged the clear evidence of his talent. The sensation which his pictures caused in the Salon was due less to the subjects depicted than to an initial lack of comprehension, which was only temporary: how could one stubbornly relinquish artistic custom and one's visual heritage and still paint so well? Courbet was able to attract connoisseurs whose loyalty was both passionate and boundless and at the same time stir up and irritate the general public, an indisputable mark of success. Although challenged, he was not an accursed painter; quite the contrary. The misfortunes of the years after 1870, the absurd vengeance of the established order were

6

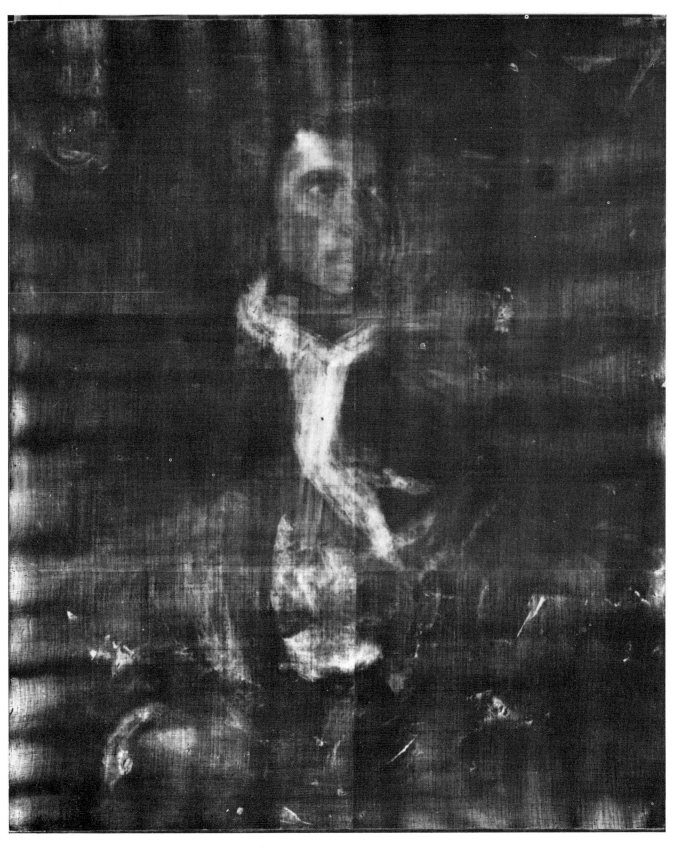

The Man with the Leather Belt. X-ray photograph revealing a copy of the «Man with a Glove» by Titian, over which Courbet has repainted «The Man with the Leather Belt», see Title Page. The picture is in reverse

on a level with his reputation. He was a victim of his own fame and was immediately placed in the Pantheon of martyrs.

His position would soon be eroded, as a new «ism» pushed out the old. Compared to the Impressionists, Courbet quickly appeared as dated as, at a previous time, Delacroix had seemed when compared with him. On the molding of the museum and the Pompeian red of the great halls of the Louvre, *The Raft of Medusa,* like *Fighting Stags* (see p. 55), *Burial at Ornans* (see pp. 22–23) or like *Sardanapalus,* have a homely family air which makes the old notoriety difficult to understand. Assuredly the works are capable of speaking for themselves and to not need the elucidations of art historians, but how can we, whose eyes are glazed by a surfeit of images, regain the freshness of vision of his startled contemporaries? How can we escape from established chronological order, a succession of movements each assigned to its proper place in a way which is perfectly sensible but has become trite and insipid? Certainly it is no longer enough to define Courbet as simply a Realist. He has no monopoly on Realism. He commented on his time with increasingly less stridency than others. As a matter of fact, did he not betray himself by more and more willingly painting landscapes, still lifes, nudes, all of which were agreeably reassuring to the bourgeois art lover?

So what of Courbet remains? If the statue quickly gathered dust, at the present time we are witnessing a renewal of curiosity: the end of a cult and the beginning of a personal credo. One should not overemphasize the importance of one aspect of the painter, which might be thought more important or more attractive, at the expense of another, for example the Realist or the landscapist, but rather one should accept the man and his talent in all their diversity. Courbet is not monolithic. Thus, for a critic such as André Fermigier, who changed our way of looking at the artist, the Courbet of the *Woman with a Parrot* (see p. 66) deserves as much attention as the Courbet of the *Burial.* Courbet is first of all a sensual, lyrical painter, moved as strongly by a bouquet of flowers as by the sight of wretches along the highway. Although he is known primarily for his manual skills, Courbet thus demonstrated a depth and a complexity of character which, together with Millet and Ingres and for the same reasons, make him one of the great poets of the nineteenth century. Curiously enough, at the same time this painter, who had probably painted too much, had seen his work reduced to just a few pictures, which were reproduced and shown again and again. Recent exhibitions have led to the reappearance of unusual paintings that had been forgotten since they did not fit in with the general impression of Courbet's work. On the occasion of the exhibition held in Paris and London in 1977–1978, an unexpected Courbet was proposed: firstly (which is perfectly correct) a knowledgeable painter with a real culture which could match Ingres in its historical dimension, but also (which is more debatable) a thinking, secret painter whose pictures, and in particuliar the *Burial, The Departure of the Fire Brigade* (see pp. 26–27), *The Artist's Studio* (see pp. 34–35), are trying to convey a political and spiritual message, linked with Freemasonry, socialism and the complex relationships with the new government, from an opponent who continues with the dialogue. There were too many unanswered questions in these famous pictures to which the key had to be found. Hélène Toussaint had the great distinction to suggest one at last. The discussion is now open (we personnally still have doubts about the Freemasonry theory, as long as the proof of his connection has not been established), but at least it is based on new factors. Courbet is now undergoing a major reassessment and can be viewed in a new light. A new Courbet can now be contemplated. Behind the leader of a school of his own, we find something which is both banal and extraordinary, namely, a man, a poet, the painter and his world; we see that he breathes the air, the pleasures and the blandishments of the Second Empire, that he conceals the formidable secrets of the 1848 revolutionary, socialist, conspirator and Freemason.

It is not to Courbet's life story, of course, that we should look for the answer to the secret. It would even be advisable not to attach too much significance to the painter's eccentric behavior, his clamorous pronouncements, his hyperbole. «Everyone agrees that I am the first citizen of France,» he declared after refusing the Legion of Honor which the liberal Empire regime awarded him in 1870. His decision was motivated as much by the shocking sensationalism of the act as it was by the painter's personal convictions: «The action I have just taken was a marvelously effective move; it is like a dream; everyone is envious of me . . . I have so many orders that I cannot fill them all.» Courbet's arguments with those in power did not hurt him in the long run. The decision in 1855 to isolate himself from the herd and to show all of

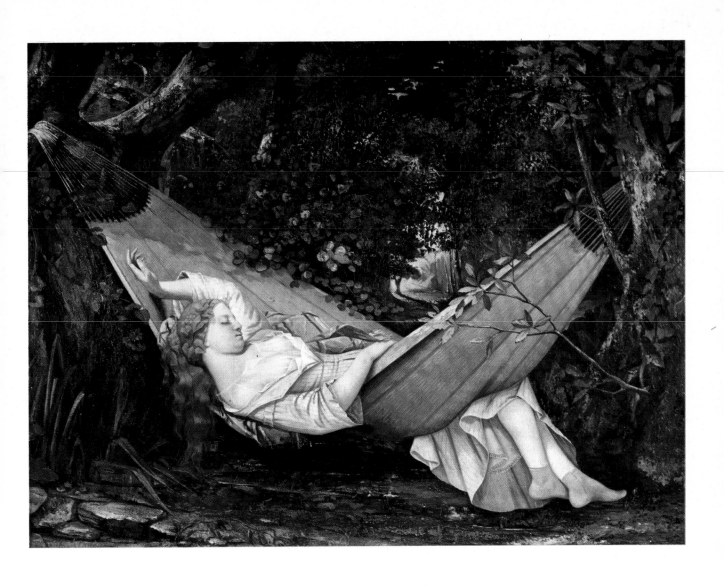

THE HAMMOCK OR THE DREAM, 1844. Oil on canvas, 27⁹/₁₆″ × 38³/₁₆″ (70 × 97 cm.)
Collection: Oskar Reinhart «Am Römerholz», Winterthur

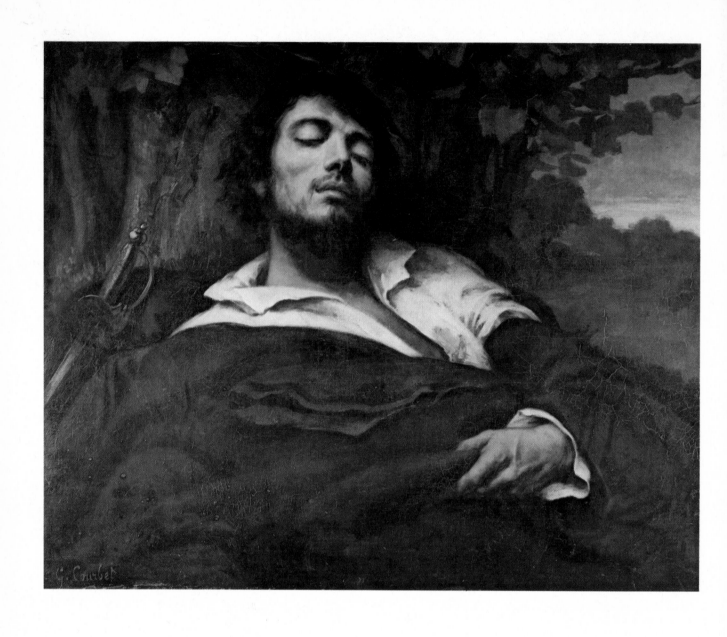

Wounded Man, 1844–1855
Oil on canvas, 32½″ × 38⅜″ (81,5 × 97,5 cm.) Louvre Museum, Paris

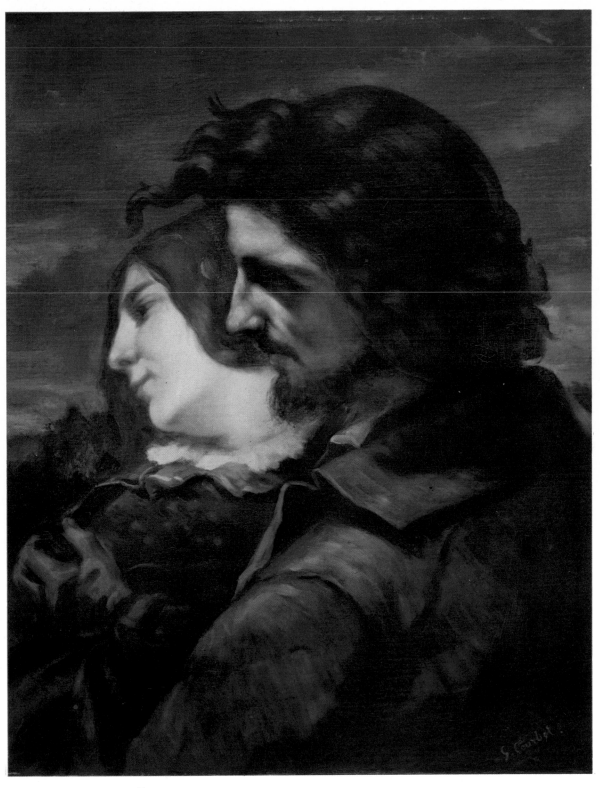

Lovers in the Country or Youthful Emotions, a repeat of the picture dated 1844 in the Museum at Lyons. Oil on canvas, 30⅝″ × 23⅝″ (77 × 60 cm.) Museum of the Petit-Palais, Paris

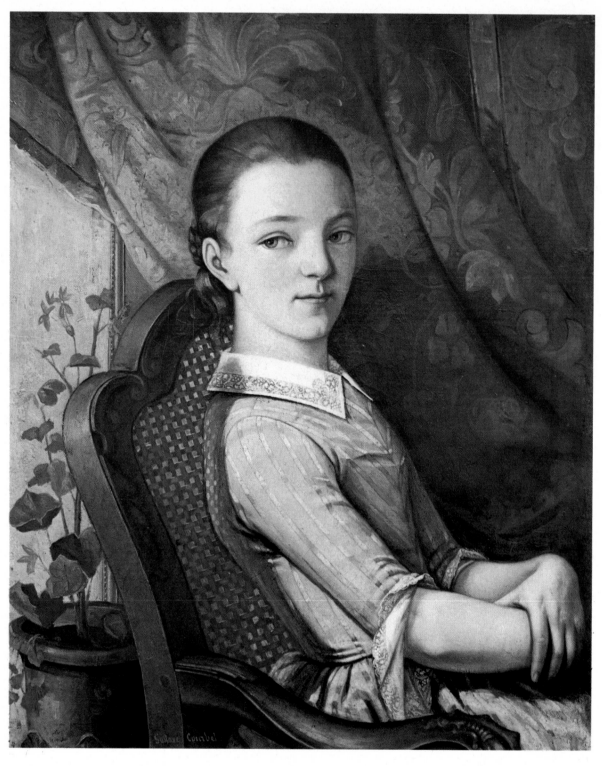

PORTRAIT OF JULIETTE COURBET, dated 1844
Oil on canvas, 30^{11}/$_{16}$″ × 24^{3}/$_{8}$″ (78 × 62 cm.) Museum of the Petit-Palais, Paris

his pictures in a separate pavilion was as much an act of rebellion and of courage as it was a promotional operation organized by a master of publicity. As a matter of fact, he repeated the venture in 1867: «I have constructed a cathedral in the most beautiful spot in Europe, on the Alma Bridge... I am stupefying the entire world.» Courbet knew how to take care of his own interests very well indeed, using the most advanced marketing methods; showing his pictures in foreign countries and also in exhibitions in the French provinces. But a profound confidence in his own worth underlaid and justified his activities. How can one reproach him for that? If the social painter was flattered at being triumphantly received in high society and by frequent visits to the chalet of the Choiseuls in Deauville, as well as by visits to his studio by «more than two thousand ladies»; if the Republican who opposed the Empire politically kept up somewhat complex relations with the administration in power, in a sort of reciprocal game of seduction and breakup; if it is possible to point to a whole collection of witticisms and tall stories (did he not pretend to Silvestre that he had had a conversation with Hogarth, who died in 1764?), all of that is without great importance. It is the legend of Courbet.

In fact, Courbet's life was notable rather for its regularity, his loyalty to his friends, his parents, his country. The part that Ornans, to which he returned regularly to paint, and his family, played is his life, the energy with which he attacked his work, his fierce determination to succeed — «I want,» he wrote in 1845, «to do great paintings... it is vital that I make a name for myself in Paris within five years» — are the things which undoubtedly really counted. All of the rest was accidental. The most extroverted of men remained a painter of landscapes. «To paint a countryside, one must know it well. I know my countryside and I paint it. The undergrowth is by our house; that river is the Loue, the other one the Lison; those rocks are the rocks of Ornans and of «Puits Noir» (Black Pit). Go and look at them, and you will recognize them in my pictures.» When he traveled to Montpellier to the Bruyas', to Saintes to Etienne Baudry's, to Germany to Munich, he extended his visits; in a manner of speaking, he had to tame and gain control of creatures and things. Like an animal, Courbet took possession of territories which he subsequently explored for a long time before settling down in them. Just as important as the memorable sessions at the Andler restaurant which helped him in Munich to win a victory over German beer drinkers, were incidents which are not known or poorly understood: promenades, poaching sessions, evenings with friends, the emotions felt before the body of a woman, a dead doe or a bouquet of flowers. A biography of Courbet must come very quickly to the core of his life, to his pictures, to his prodigious determination to paint, the the mystery of the years in Paris, where Flajoulot's pupil from Besançon, who arrived in the French capital in 1840, was capable of exhibiting in the Salon as early as 1844 *Lovers in the Country* (see p. 11), *Self-Portrait with Black Dog* (see p. 5), *The Hammock* (see p. 9); in other words, the works of an accomplished artist, the master of his medium, which immediately established his reputation. For indeed the most important aspect of Courbet's biography is his pictures; it is the astonishing adventure which they represent that one should try to follow.

ONE SCANDAL AFTER ANOTHER

The years 1849–1855, as fruitful as they were glorious, were for Courbet a little like the Italian campaign for Bonaparte. Like Napoleon's victories, Courbet's masterpieces followed one another in quick succession. Six pictures were offered to, and accepted by, the Salon of 1849, including *Burial at Ornans, Peasants of Flagey, The Stone Breakers* (see p. 39). In 1852 he showed *The Village Maidens* (see p. 28); in 1853 *The Bathers* (see p. 33); in 1855 *The Artist's Studio* and a special showing of his works on the occasion of and alongside the International Exposition. Courbet's action shocked and caused a sensation, but he left no one, from then on would never leave anyone, indifferent. All of his works, hung from the moldings on museum walls, would henceforth be «classics.» It is up to us to look at them without too great reverence, if that is possible, and to try to experience a little of the surprise felt by Courbet's contemporaries.

After Dinner at Ornans was Courbet's first great success. If we can believe Francis Wey, who may have been exaggerating a bit, the picture attracted the attention of the two «popes» of the painting

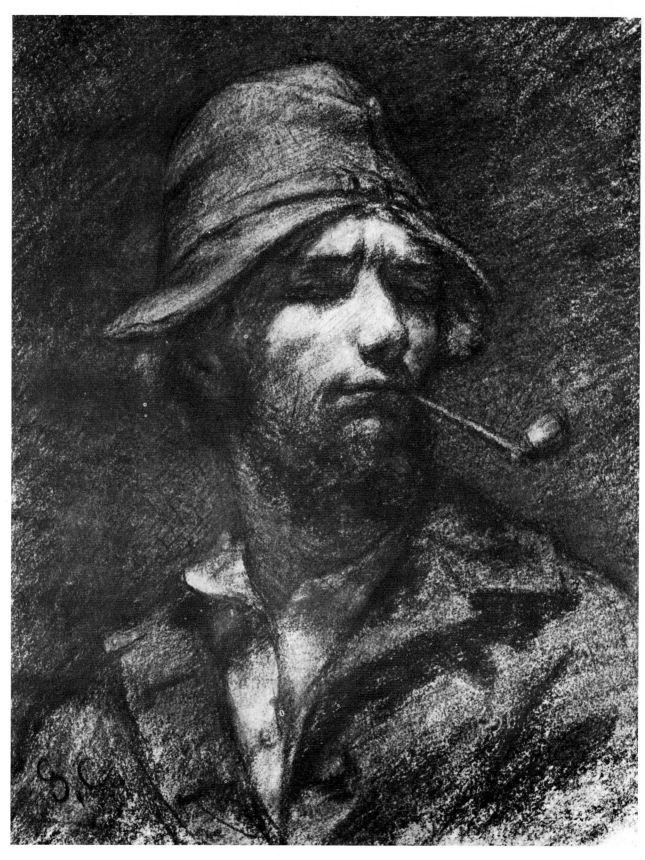

Self-Portrait, around 1848. Charcoal on paper, 11″ × 8¼″ (28 × 21 cm.)
Wadsworth Atheneum, Hartford, Conn.

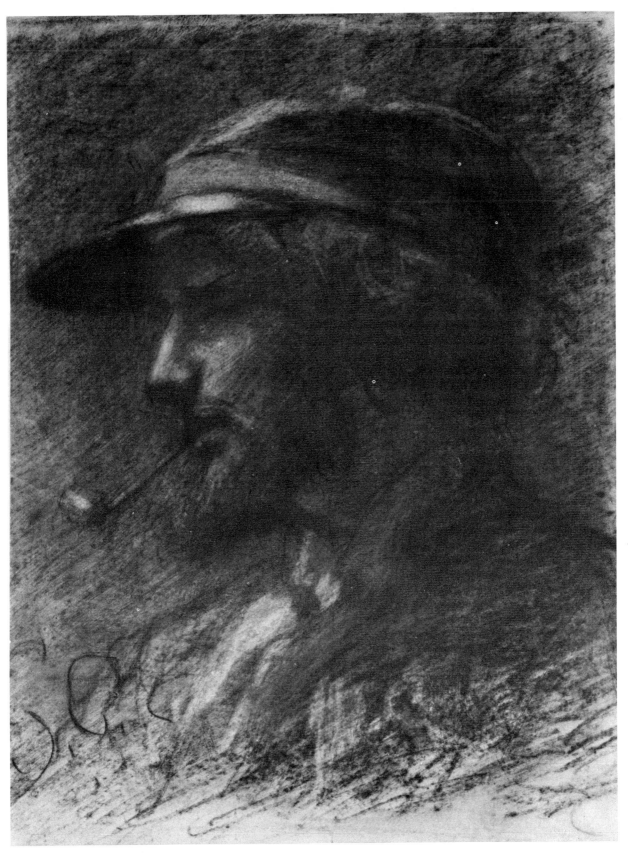

Portrait of the Artist with a Pipe, around 1844. Charcoal on paper, 7³⁄₈″ × 5½″ (18,7 × 13,9 cm.)
The Fogg Art Museum, Harvard University. Greenville L. Winthrop Bequest

hierarchy; Ingres and Delacroix, no less, deigned to pick it out from among the thousands of canvases displayed. «There is an innovator, there is a revolutionary, who suddenly bursts on the scene in a way which is unprecedented,» declared Delacroix. «What a waste of talent. It is amazing and heart-rending. The composition — nothing. The drawing — nothing. . . . This lad is an eye personified,» echoed Ingres, What appeared revolutionary may well have been the contrast between the seemingly insignificant subject and the ambition and sweeping nature of the technique. Such a big format for such a minor scene, treated so grandiosely! Genre scenes, at least according to Dutch tradition, required close and careful study precisely because they occupied a small space and suggested that there was more to understand than is visible at first blush. If the format became larger, it was to portray important acts of social and municipal life. The four gentlemen who have finished dinner and are playing the violin, dozing, listening, smoking, have none of the importance which characterized the judges, officers or administrators portrayed by Hals, Van Helst or Rembrandt. They are undoubtedly relatives and friends of Courbet (today one can religiously cite their names: Régis, the father, Promayet the musician, Adolph Marlet who is lighting his pipe, Courbet or rather Cuénot who is listening), but they are primarily ordinary, everyday men in the French provinces of the 1850's.

It was scandalous that a piece so imposing, which did not depend on psychological or descriptive research (certainly he had at home better documents on the Franche-Comté) should be painted with such vigor. Like Castagnary, one could evoke with emotion the atmosphere and the friendships of Ornans and of Flagey, but what remained were people, like those of Caravaggio or Le Nain, and perhaps for the same reasons, capable of speaking to those far removed from the Via del Babuino in Rome or the French countryside. What shocked Delacroix was that it was a painting which spoke so softly, and perhaps had more to say because it spoke to humanity. Ingres' art demonstrated a vast pictorial skill cohabiting with a vast indifference. Certainly Courbet did not invent realistic painting, but offered such a stark vision of it that it could not fail to surprise. In contrast to all of the historical, social and psychological implications contained in a canvas by Meissonier, Courbet apparently restricted himself to a single motif and refused to embellish reality: the painter contented himself with working from a model, at the risk of provoking, as did Manet, discussions so dear to contemporary critics on pure painting. We must react to that, however. *Olympia* may be a harmony in rose and black, but it remains the body of a woman, specifically Olympia. Courbet's diners remain intimate friends of Ornans, captured in a moment of everyday life.

This balance, so difficult to achieve and to understand thoroughly, was constantly being upset by the painter as well as the public; by the public, we must confess, before the painter did it. The reaction to *Burial at Ornans* bears witness to the fundamental misconception which would tarnish Courbet's artistic reputation. At the Salon of 1851 he was a success and also created a scandal; these two sides of the coin, as usual, reinforced one another. «Never,» stated Delécluze, the critic of the «Journal des Débats», «has the cult of ugliness been espoused so frankly.» Courbet was not satisfied to reproduce reality, even in its most trivial aspects. He blackened, reviled, ridiculed his subjects; he systematically set about *making them ugly.* In the opinion of Théophile Gautier it was very close to caricature; at most it derived from Daumier, was a larger version. The two beadles especially, «with their bloated faces smeared with vermilion, their inebriated attitude,» were grotesque figures. Courbet had scoffed at his compatriots, to the great amusement of Parisians.

It is a problem of interpretation. It is clear that Courbet surely did not wish to make people laugh at his models, or use them, without their being aware of it, to make other points. Te *Burial* was conceived and painted in Ornans in 1849 and 1850. The entire village participated in the enterprise and competed with one another for the honor of being «shot.» «The mayor, who weighs 400, has already posed, also the parson, the justice of the peace, the cross bearer, the notary, the deputy mayor Marlet, my friends, my father, the choir boys, the ditch digger, two old veterans of the '93 Revolution in the clothes of that time, a dog, a corpse and its pallbearers, the beadles (one of the beadles has a nose like a cherry, but proportionately large and five inches long), my sisters, other women, etc. I did intend to by-pass two cantors of the parish, but it was impossible; someone came to warn me that they were annoyed,» Courbet related to Champfleury. How can one believe that he was making fun of his fellow-citizens, of the people to whom he was so attached? Certainly J.-B. Muselier, the vine grower, and the shoemaker Pierre Clément, the beadles in superb red robes, had highly colored and bloated faces and were noticeably picturesque, but they were part of the Ornans world. The corpulence of Mayor Teste de Sagey was famous among his constitutents. It may have provoked smiles, but these were certainly not unfriendly. Courbet depicted what everyone saw. Assuredly Ornans did not anticipate the reaction of Paris and accepted with poor

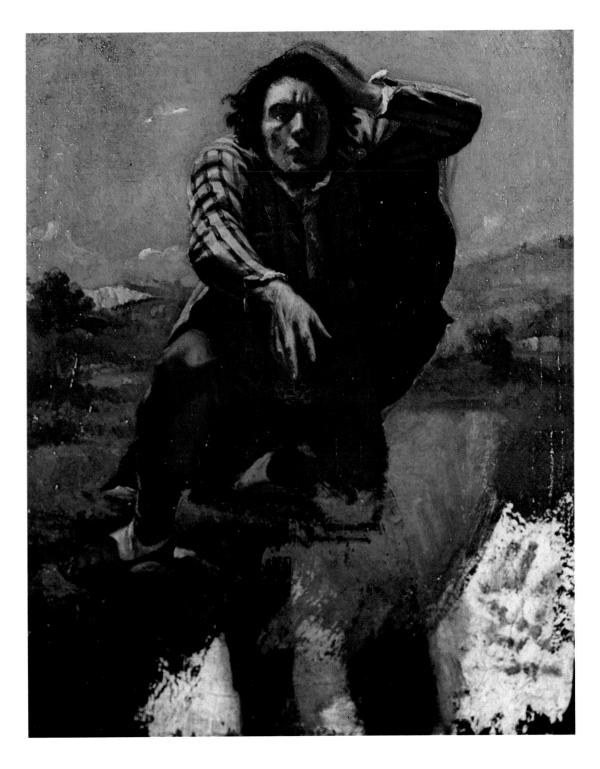

THE DESPERATE ONE, 1844–1845
Paper glued on canvas, 23^{13}/$_{16}$″ × 19^{7}/$_{8}$″ (60,5 × 50,5 cm.) Nasjonalgalleriet, Oslo

grace the notion that it was being ridiculed and was amusing people throughout France. At least Courbet did not have a falling-out with Ornans, and that alone absolved him from any accusation that his intentions were bad; indeed, quite the contrary was true.

Champfleury was undoubtedly right when he declared, «Mr. Courbet wanted to portray a small-town funeral, such as take place in the Franche-Comté; and he painted fifty persons, life size, on their way to the cemetery. That is the whole picture.» And in fact that is the whole picture, which brings together a slice, a sample of the population of Ornans and describes it trough the burial of one of its own. But in saying this one is really saying nothing. Neither handsomer nor uglier than anyone else, the inhabitants of Ornans, by the grace of Courbet, testify for all of humanity. As large as life, occupying the whole expanse of the canvas, they are a modern version of the old Greek festival dedicated to Athena, and even though, models by chance, they are not endowed by especially expressive visages, they have the responsibility of expressing the varied emotions of sorrow, compassion, indifference, etc. through which human nature can be defined. And they manage to do this for better or for worse, do it as well if not better than the models carefully selected by Charles-Louis Muller for the huge (and really remarkable) work, *Cry of the Last Victims of the Terror,* which was featured in the same Salon and served as a foil to Courbet vis-à-vis the critics: truth confronting reality, the characteristically dependable confronting the temporary; that is to say reassuring evidence that nothing is less true, basically, than the real, since it does not allow for the achievement of permanence. At least Ornans, or more accurately the Ornans dear to Courbet, was in microcosm all of the subject matter which Courbet wanted to treat, and was neither greater nor less than what might be found anywhere else. Realism, if understood as being true to life and not susceptible to being idealized, that is to say if nothing can be added to or subtracted from the proposition which exists, if the subject is not shown as either more or less than it is, in no way presents an obstacle to majestic and expansive painting. That is the lesson of the *Burial.*

But there is more. In Ornans, it seemed, the human comedy was played with a special kind of grandeur. Was it because of the vestments and other costumes? The hats for the pallbearers rented from friend Cuénot, the famous red robes of the beadles, which may have looked like carnival raiment to the Parisian critics, added to the gravity of the ceremony. The harmonious blending of black, red and white gives to this country rite the splendor of a state funeral. It recalls to mind the great Spanish and Dutch canvases. «The simplicity of the black costumes has the grandeur of the red robes of Parliament painted by Largillière,» remarked Champfleury, with his customary insight. This grouping in Ornans takes its place naturally among the great personages painted during the most important moments of their existences.

Moreover, the actors play their parts rather well. Persuaded or not, good-looking or homely, assuming their roles willingly or reluctantly, they exude a natural dignity, arrange themselves in formation below the cliffs of Ornans like another wall, a wall of the living facing the emptiness of death. It is difficult to understand today how this picture could have inspired laughter and been taken for caricature, so removed is it from any suggestion of sarcasm. A religious picture? Surely, even if Courbet was by no means a churchgoer. But must one indulge in confession in order to participate in the ritual of death? There are some marvelous things in this painting. The skull, taken from the earth and positioned beside the hole, is a detail more eloquent than it is true to life (would the gravediggers have left it there, even if it is conceivable that they dug a hole in a place already occupied!) Such implausible details indicate and remind us, in case we need reminding, that this burial in Ornans, with a format as vast as its aspirations, is, if not a picture with a message, at least a *significant* one. A simple funeral in Ornans (Doubs) in 1849 will henceforth bear witness to the condition of man as he meets his fate.

The Stone Breakers, painted in the winter of 1849 and shown in the Salon of 1850-1851, is similarly inspired: an apparently objective interpretation of a reality which made a particularly profound impression on the man and the painter Courbet. A letter from Courbet to his friend Francis Wey, written on November 26, 1845, gave extraordinary testimony as to the sources of his inspiration. Courbet announced that he had a vision. «I took our car. I drove to the château Saint-Denis to do a landscape; near Maizières, I stopped to look at two men breaking stones on the road. It is rare to find an expression of such utter and complete misery; and at once I had an idea for a picture.» It was already a Proustian experience. The concept of a picture came to him suddenly, immediately, as Proust later experienced the resurfacing of a recollection of time past. The subject, the composition and the pictorial effect all etched themselves on his inner eye simultaneously.

In the balance of the letter Courbet described his picture to his correspondent with the objectivity and the analytic attitude of a realistic novelist: «There is a seventy-year-old man hunched over his work,

his head shaded by a straw hat; his trousers, of a coarse material, patched together; and inside his cracked sabots, once-blue socks which reveal his heels.» And he added, without any transition: «The old man is on his knees, the young man is standing behind him . . . alas, it is in this state that one begins, and it is thus that one ends up.» The subject abruptly takes on a new dimension: meditating on human destiny, on the narrowness of the universe in which this category of laborers is enclosed, without hope. But the message remains implicit. The photographs (the only evidence with which we are left since the destruction of the picture in Dresden during the Second World War), show that the gaping holes in the shoes, the tears in the clothes were not depicted with what we would call today a super-realistic meticulousness which would have an educational value. *The Stone Breakers* does not teach and does not attempt to describe misery; the heroes are even devoid of expression, their faces being concealed by the shadow cast by the hat or the view of the back. The emotion aroused by the work is not intense; it is characterized by a great simplicity, by the matter-of-factness of the artistic technique employed to portray this scene at the side of the road. Today the comments of Claude Vignon, a not too unastute critic of the period, appear to us to have been completely beside the mark when he declared that Courbet wanted «to depict as crudely as possible that which is revoltingly foul and crude.» Another critic, Sabatier-Ungher, more accurately attributed to this painting «a somewhat tart . . . but healthy pungency, a taste of well salted bread . . . it has a relentless naturalism . . . but there is nothing vulgar about it . . . the rags have a great amplitude.» Or grandeur, perhaps.

One should not be too surprised by the reproach so frequently made by the commentators of the period that Courbet made «ugly» pictures. It would oversimplify if one saw in it merely the prudish reaction of the newly triumphant bourgeoisie, suddenly elevated to the rank of art critics, the persons who delighted in making fun of Daumier. After all, that had even been the experience of Caravaggio. All of the realistic painters, all of the champions of dark paintings, in their time must have seemed «ugly» or «dirty» when contrasted with the light, bright painters who had the advantage of being in the academic tradition. Besides, this fortune befell many others — Delacroix and also Ingres, whose drawing was found to be unrealistic, and the goitrous throats of Francesca or Thétis hideous. The problem on each occasion was that visual habits had to be broken, and the difficulty for us is understanding exactly, years afterward, the precise reasons for the hostility. It was not the portrayal of stone breakers which was capable of shocking. Géricault had painted many scenes which were considerably less edifying. Holes in a shirt or cracked shoes could hardly upset a public which was accustomed to gazing at far coarser details in the canvases of Horace Vernet. Then how explain the reaction? Perhaps the answer should be sought in the feelings produced by the canvases painted with massive strokes, canvases in which Courbet did not need to say anything else or suggest anything more than what existed, and in which for that very reason he could speak strongly. If the hallmark of a masterpiece is a return to basics, Courbet, a sort of Masaccio of the 1850's, offered anew to eyes wearied by too many canvases which employed too many classical or romantic formulas a feeling for simplicity. More dangerous than Horace Vernet or Delaroche, who were mediators, he appeared to be a veritable third man and thus aroused particularly violent reactions.

The Village Maidens, in the Salon of 1852, illustrates this phenomenon of an absurd and paradoxical opposition to Courbet's work. Some of the critics sounded once again a trumpet blare against ugliness. The three maidens, who happened to be the painter's sisters (Zoé to the right, Juliette under the parasol and Zélie facing the little girl) were judged «awkward and vulgar.» This was the opinion of Gustave Planche and was shared by Théophile Gautier, who was generally more perceptive, and who found that the unfortunate Zélie looked «like a cook in her Sunday clothes.» Even the dog, a «frightful little mongrel . . . a disgrace to his mother,» testified to the impulse to ridicule which Courbet set in motion. The cows were Lilliputian, the rocks unrecognizable, etc. Ever since *Burial at Ornans,* according to the critics, Courbet had stubbornly persisted in showing his scorn for the human race and had consistently evidenced clumsiness and a cult of the grotesque. And yet Courbet had consciously tried to appeal to the unbelievers by introducing «graciousness»; the incident of the three ladies giving alms to the poor girl herding the cows is easily read, easy to understand, and indeed appears inspired by a genre scene. It is no longer a painting which is enigmatic by the very fact of its simplicity, as was *The Stone Breakers.* Today one is tempted to prefer the sketch of Leeds to the large composition in the Metropolitan Museum; the smaller format, which makes for a more concise definition, renders more sensitively the boldness of the two groups, humans and animals, squarely set in the green of the great panoramic landscape with a precision which is reminiscent of Brueghel. Courbet, untouched by the theories of the classical landscape artists such as Aligny or the Romantics such as Théodore Rousseau, invented a new kind of landscape in

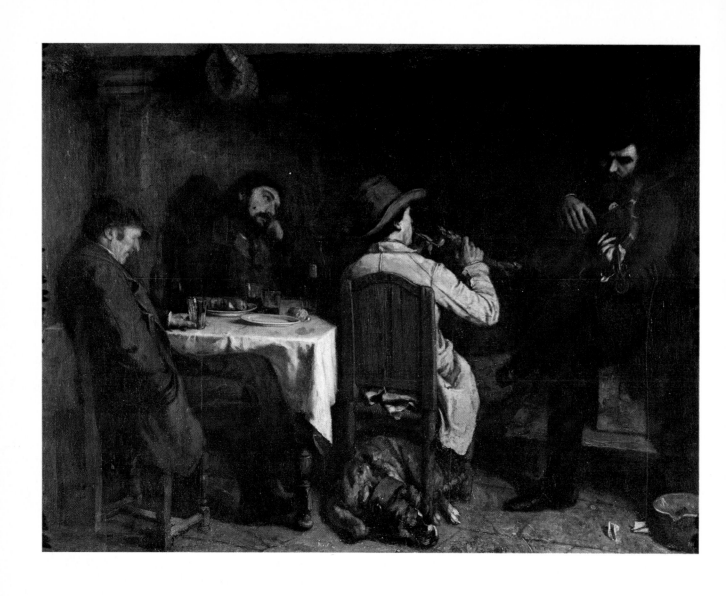

After-Dinner at Ornans, Salon of 1849
Oil on canvas, 76³/₄″ × 101³/₁₆″ (195 × 257 cm.) Museum of Art and History, Lille

20

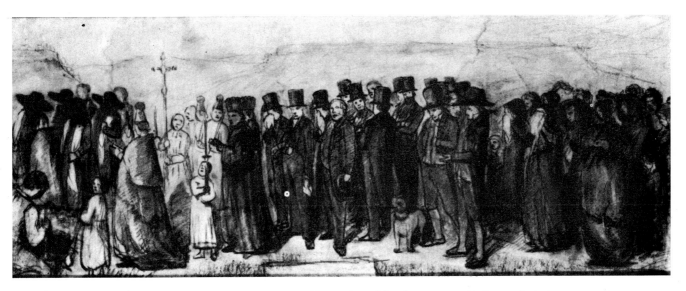

A Study for Burial at Ornans, 1849. Charcoal on bluish paper, 14³/₁₆" × 37" (36 × 94 cm.)
Museum of Beaux-Arts, Besançon

which realism achieved a heroic quality through the simplicity, one might almost say naïveté, with which the various elements of the composition were brought into play.

Courbet's demonstrated capacity to master various techniques and, notwithstanding the simplification of the critics, to achieve an output which was manifestly complex was clearly apparent in the Salon of 1853, where he exhibited *The Wrestlers* (see p. 32), *The Bathers, The Sleeping Spinner;* in other words, works which could be expected to be both shocking and reassuring at the same time, while revealing the artist's ability to resolve more and more intricate pictorial problems. In *The Wrestlers,* today in Budapest, as well as in *The Bathers* (Montpellier), Courbet tackled nudes. The two pictures were hung one above the other. As a result one could not help being struck by their dissimilarity and at the same time by their kinship: two masculine figures, two feminine figures; nudes seen from the front in the first case, from the back in the second; powerful forms treated with a tautness, an intensity of expression, a taste for the excessive and the superfluous which transports us into the universe of the Italian nude, into the world of forms and postures where, from Michelangelo to Rubens, the adventure of pictorial creation has ceaselessly unfolded.

Delacroix was exasperated by the insignificance of The Bathers. «The vulgarity of the forms does not concern me; it is the vulgarity and the pointlessness of the thought which are abominable; in spite of that, it would not be so bad if only the idea, whatever it is, were clear!» In fact, there was no explanation of the outstretched arms of the two women. The «exchange of ideas» between the bathers which Delacroix vainly sought to understand, did it really exist? It remains elusive; perhaps the question posed by the picture is addressed solely and simply to the problem of the nude in a landscape, as if Courbet were trying to overcome every obstacle painting had known since the Renaissance. *The Wrestlers* may have seemed less puzzling; the hold (a kind of half nelson) with which one is gripping the other is at least a simple move which is consistent with the limited nature of the subject. And yet there too one is obliged to evoke certain archetypes; all of the pictures of Hercules with the Nemean lion or with the giant Antaeus who, from Guido Reni to Delacroix, have afforded artists the opportunity to show man in motion and making a strenuous effort.

Undoubtedly there was some cause for irritation in the puffiness of the flesh, the fatty buttocks of the bathers, the extreme muscularity of the wrestlers at the fair. The jutting veins on the athlete's legs, which threaten to burst, and the sock of the seated woman were also seen as being vulgar and outrageous. But whereas Courbet's contemporaries might have been surprised and shocked at such a treatment of an academic theme, we today are more impressed by the fact that he was willing to handle such subjects. Is

21

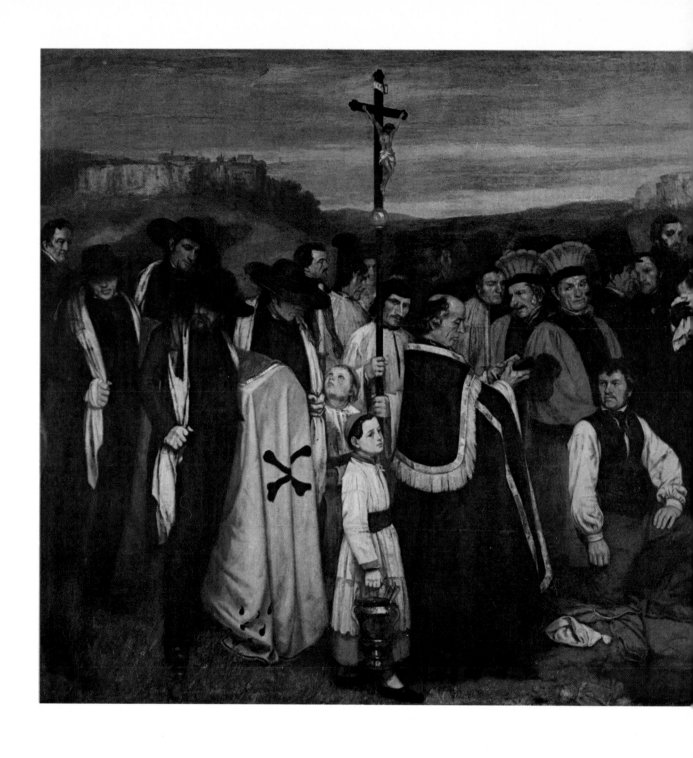

BURIAL AT ORNANS, 1849–1850
Oil on canvas, 123⅝″ × 261¹³/₁₆″ (314 × 665 cm.) Louvre Museum, Paris

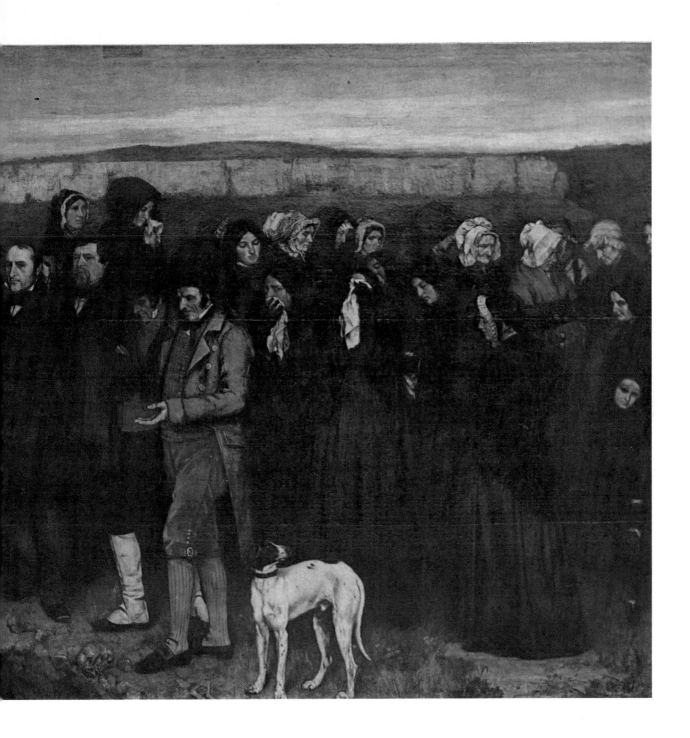

Courbet's bather so offensive to Ingres' Valpinçon? Do not these two beauties, seen from the back, although certainly representing very different schools, share a common unreal quality, or more exactly a common bond with the tradition of academic study which aims to discover all of the changes which can be rung by diverse and innovative talents. Ingres, blotting out the hips, obliterating the vertebrae and stressing the function of the limbs, and Courbet, piling bulge on bulge, thickening the calves, choosing models who are cows rather than sylphs, still, at least to eyes less than a hundred and fifty years old, seem to have had the same passionate determination to reform old habits and old mannerisms and, very simply, to transform the old way of doing things. It happened that they were struggling against different enemies and chose opposite methods of registering their views; but from the point of view of history what differentiated them was secondary, in view of the similar forcefulness of their adherence to change. The «beautiful» and the «ugly» were transmuted with equal effectiveness by Ingres and by Courbet.

In *The Bathers* Courbet confirmed the fact that what he was interested in was «monumental painting.» The choice of subjects selected from real life did not represent a radical break with tradition. The selection of large formats in itself indicated his conviction that an insignificant scene deserved the same honor and also the same dimensions as a mythological, allegorical or historical subject. In any case *The Bathers*, a new *Bath of Diana*, but this time a Diana accustomed to the undergrowth of the Franche-Comté, come from the streets and villages of the period, gave assurance that for Courbet, Realism did not lie in the choice of a subject, a systematic selection of the ugly as opposed to the beautiful, but primarily in breaking off old habits, cleansing the eye and giving the tongue a taste of salt.

The Sleeping Spinner (see p. 25) completes the demonstration. It is a calm and tender picture; the breathing is silent. Alongside the «Hottentot Venus» whom Napoleon III would have horsewhipped, the «Mare» whom the Empress deemed worthy of being featured in «The Horse Fair» of Rosa Bonheur, a stone's throw away from *The Wrestlers*, smeared, according to Théophile Gautier, with coal and soot instead of the traditional oil, Zélie, a sister of the painter, asleep over her work, evinces Courbet's sensitivity and his capacity for controlled emotion. The subject is placed realistically in familiar surroundings, and it is not easy to define its social meaning. Was the spinner truly a «proletarian», according to the explanation which Courbet actually gave Proud'hon? Whether the model is Zélie (and this traditional identification has recently been contested, wrongly, in our opinion) or a cowmaid, as Courbet himself claimed, or a serving maid, according to Théophile Gautier, the sleeping woman could certainly play this role, but she does not cast an aura of misery or hunger. The shawl and the material of the dress perhaps suggest the small town rather than the big city, but the cloth on the table, the upholstery of the chair bring to mind a homely and comfortable room of the middle class. Are we facing one of those big-hearted servant girls dear to Baudelaire or possibly even a «lady» from the village, who is spinning only to please her painter brother? Whatever the case, women spinning, like bathers, are not newcomers in the pictorial universe: from Heemskerk to Le Nain, from Velasquez to Scheffer, the theme of the spinner has given rise to skillful creations which combine the complexity of the lines of the spinning wheel with the mass of the figure; frequently the threads are woven into a frame for the composition. In this painting the reclining figure of the sleeping woman forms a counterpoint to the curve of the wheel, to the droopy limpness of the thread. The lines of the shawl, the red ribbon of the distaff wind around one another, weaving a nest of dreams, the concentric circles of the world of sleep. The mystery of the sleeping woman is first and foremost that of pictorial invention.

REALIST, NATURALIST, COURBETIST?

1855, with the thunderclap of the «one-man exhibition» at the International Exposition and the synthesis of a life represented by *The Artist's Studio*, was the high point in Courbet's career, a little like 1661, the famous date of his accession to supreme power in his own right, for Louis XIV. Courbet was able to rid himself of the label of Realist which had made him famous and to take his place proudly simply as Courbet. He devoted himself to a retrospective analysis of his career, and with *The Artist's Studio*, his *Meninas*, showed himself to be a new Velasquez, and at the age of thirty-six drew up a balance sheet which would herald a program of inestimable value for his future.

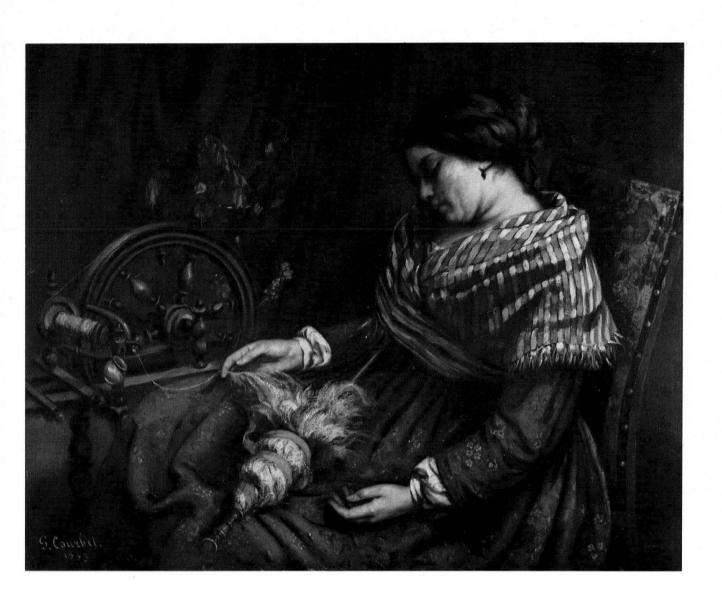

The Sleeping Spinner, Salon of 1853
Oil on canvas, $35^{13}/_{16}'' \times 45^5/_{16}''$ (91 × 115 cm.) Fabre Museum, Montpellier

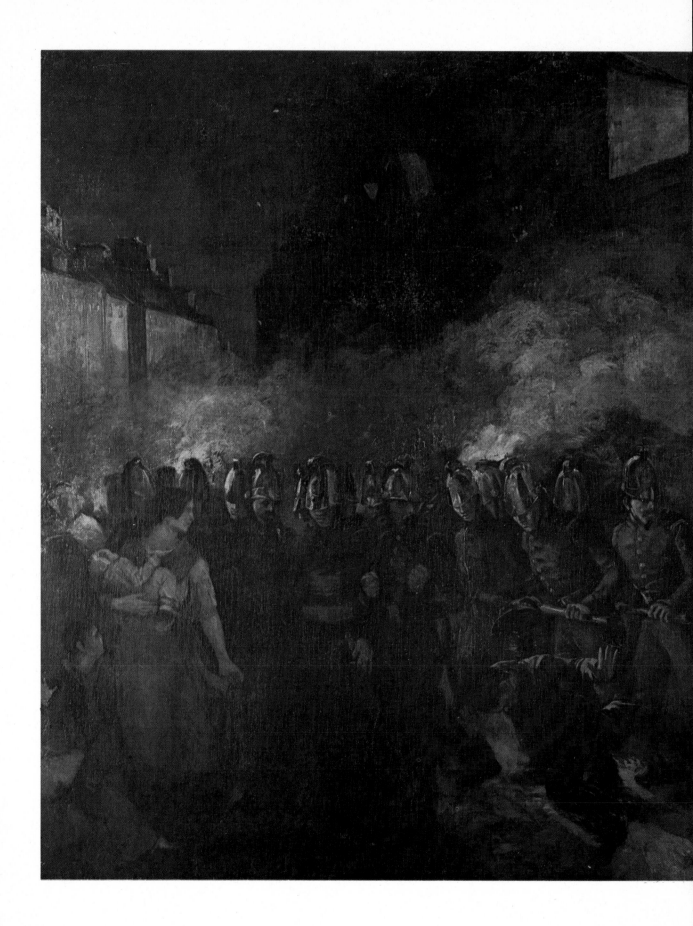

THE DEPARTURE
OF THE FIRE
BRIGADE, 1850–1851
Oil on canvas,
152¾″ × 228⅜″
(388 × 580 cm.)
Museum of the
Petit-Palais, Paris

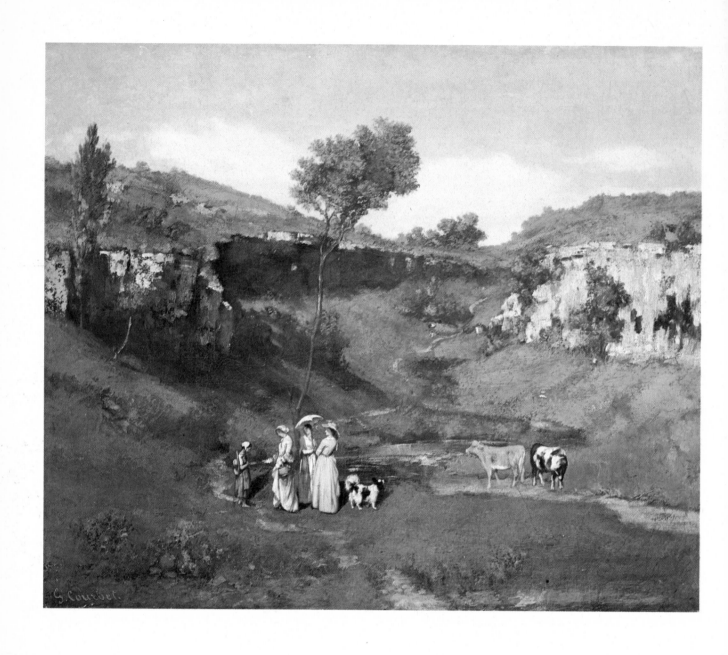

THE VILLAGE MAIDENS, 1851. Sketch of the painting presented at the Salon of 1852
Oil on canvas, 21¼″ × 25¾″ (54 × 65,4 cm.) City Art Gallery, Leeds

Siesta, around 1844. Drawing with charcoal and print, 6¼" × 7⅞" (16 × 20 cm.)
Museum of Beaux-Arts, Besançon

His refusal to participate in the International Exposition (where the jury had rejected *Burial* and *The Artist's Studio*), the decision to construct in the enclosure a pavilion for himself alone permitted Courbet to occupy a place comparable to that of Delacroix and Ingres, who had the honor of being given special rooms. He was indeed the third man: the Realist confronting the Romanticist and the Classicist, who were already inscribed in the rolls of history. But in the catalogue published under his supervision, he took exception to the appellation. «The title of Realist has been thrust upon me just as the title of Romanticist was thrust upon the men of 1830. In no age have titles really been an accurate assessment of artists;

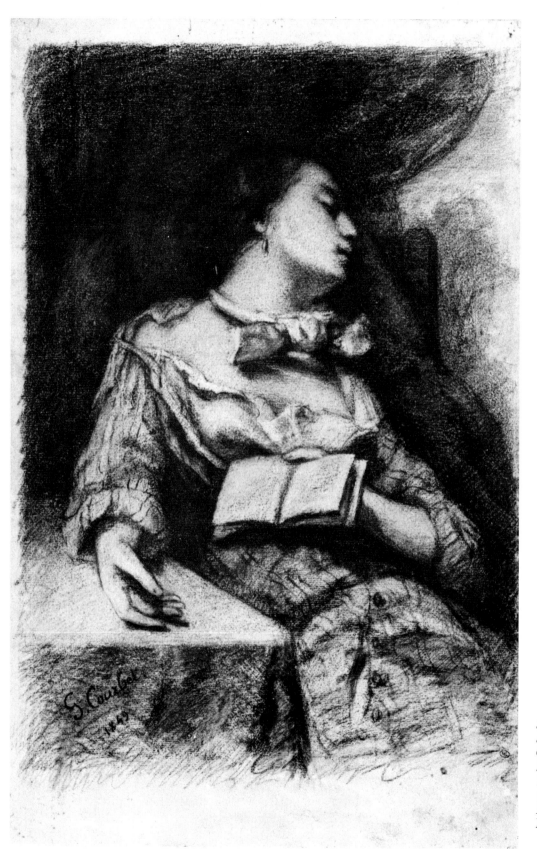

*Sleeping Woman,
dated 1849
Charcoal with
highlights in white,
18¹/₂″ × 11¹³/₁₆″
(47 × 30 cm.)
Louvre Museum,
Paris*

if they were, the works themselves would be superfluous.» In 1857 Champfleury, the coiner of the word and the founder of the movement, who carried Courbet to the baptismal font of fame, had the same reaction. «I regret all of the words ending in "ism," which are basically transition terms.» And again: «I do not like schools, I do not like flags, I do not like organized systems, I do not like dogma . . . I would find it impossible to take my place in the little church of Realism, even if I should be its god.» This was a reflex action to be expected from founders of movements, exasperated at being caged within the boundaries of their own reputations, particularly when their talent had wings and would fly. Yet that does not negate the fact that Champfleury, with his journalistic genius, invented the word (after some others) in 1847, that he made it a standard to hang high and that he found in Courbet the most popular and willing of heralds. It is thus that schools are created, that a café (the Andler, 32 rue Hautefeuille) became known to posterity, that a group of friends who took their refreshments there became the stuff of legend, and that a word entered the artistic vocabulary because it was so often repeated and construed in so many different ways by the critics, the general public and high dignitaries such as the imperial prosecutor who accused Baudelaire of Realism during the trial on «Flowers of Evil.» It is understandable that Champfleury and Courbet soon grew desirous of undermining the very legend which had been created in large part by their efforts. But it was no longer possible to destroy the legend and Courbet was destined to become, in a sense, its prisoner and even its victim.

Admittedly the definition of the term made in 1855 was perfectly reasonable. «To be in a position to interpret the customs, the ideas, the various aspects of the age as I see them, to be not only a painter, but also a man, to make living art, that is my aim». Realism, defined as the choice of contemporary subjects and the right to a personal reaction, such as the alliance between lucidity and sensitivity, objectivity and temperament, had certainly found its greatest expression in the *Burial at Ornans*. This «complete human drama, where the grotesque, fears, egoism and indifference are treated masterfully», as Champfleury says, «this funeral in a small town, which nonetheless reproduces *all* funerals in *all* small towns», is pure classicism. He is speaking both to a limited audience and to the whole world. The paradox is that Courbet did not pursue this path and further, that more was read into his works (by Proud'hon first of all) than they contained and that he was tempted to reply to the challenge by aligning himself with those who pushed him towards painting with a political message. The transition from social and personal Realism to socialist and political Realism is, in fact, one of the courses adpoted by Courbet after 1855, somewhat in spite of himself and with varying degrees of success. It must be noted that Courbet provides only a very limited description of the society of his day. A burial at Ornans, three local ladies giving alms to a shepherdess, stone breakers, winnowers, firemen departing to put out a fire, is this enough to describe the life of a people? Courbet is no Hogarth and even less a Balzac; he is not Daumier either. Champfleury suggested in vain that he should depict the major problems of the day by using the great buildings of the time. «He belongs to a century which is preoccupied by industrial ideas; let him show industry the support it can find in art . . . the only architectural style that the nineteenth century evolved was the construction of market halls and railways. Why did Courbet not make a new effort and decorate railway stations? A locomotive leaving, a train arriving, travelers disembarking, a new line being consecrated by the Church (!), the new products which steam has introduced into Europe could furnish a cycle of varied subjects . . . Are the machine and the role which it plays in the landscape not enough to make for a beautiful picture?» Granting that metallic architecture, because of its transparency and the thinness of its supports, does not lend itself well to large painted surfaces and that companies and the state did not take the desired initiative, it is likewise true that Courbet did not appear to want to risk such experiments.

It would be absurd to reproach him for this. The world of industry, we must repeat, established relations with creative artists only late in the day. It was at the end of the nineteenth century and during the first years of the twentieth century, with Menzel, Constantin Meunier and Jules Adler, that the industrial worker and trade unionists became subjects for the artist. The case of François Bonhommé (1809–1882) is an exception. A pupil of Delacroix, he exhibited as early as 1838 a view of the smithy of Ablainville in the Meuse and in 1840 a view of Fourchambault, both of which were shown at the International Exposition of 1855 without creating any great outcry. He was unable to complete his master work: a *Soldiers of Industry* which would have paid tribute to metallurgy. Worse than that, the large mural which was commissioned for the Mining School in 1859 was willfully and wickedly destroyed at the beginning of this century. The only or almost the only works which remain are a few drawings still in the Iron Museum in Nancy; only these are left to acquaint us with the output of this lone artist who represents a lost opportunity of pictorial realism. Courbet, who knew both an urban and a rural environ-

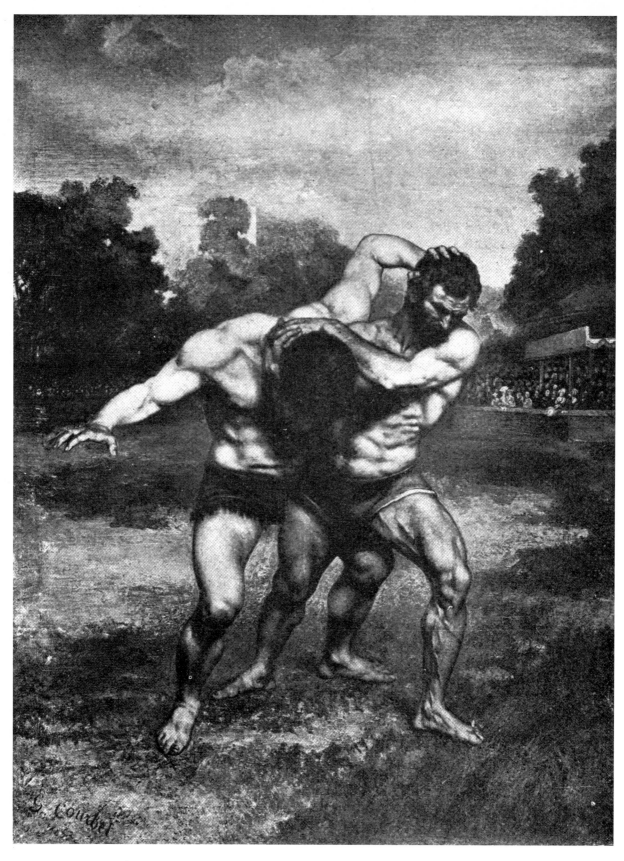

The Wrestlers, Salon of 1853. Oil on canvas. Museum of Budapest

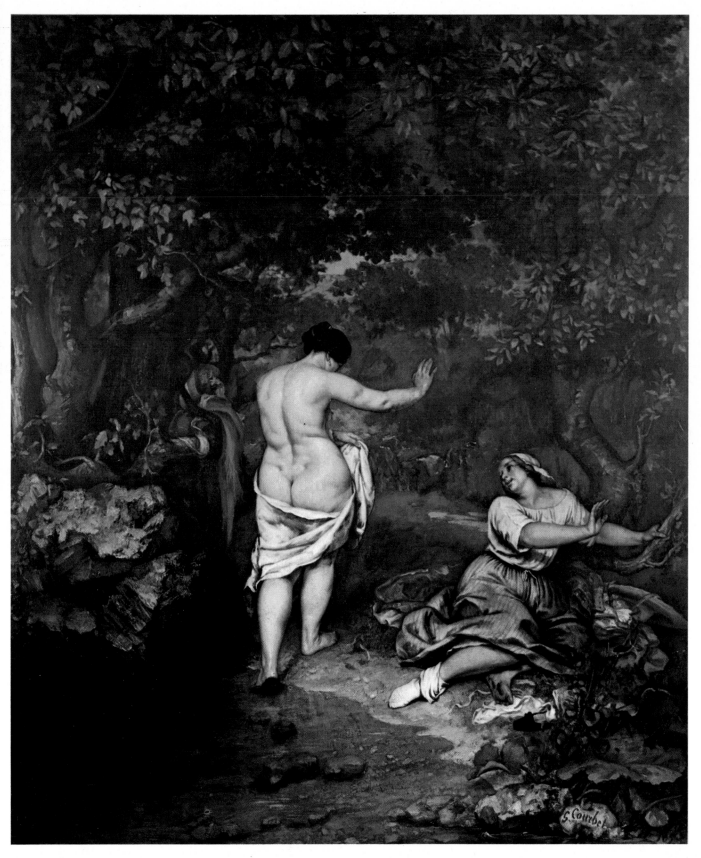

THE BATHERS, Salon of 1853. Oil on canvas, 89⅜″ × 76″ (227 × 193 cm.) Fabre Museum, Montpellier

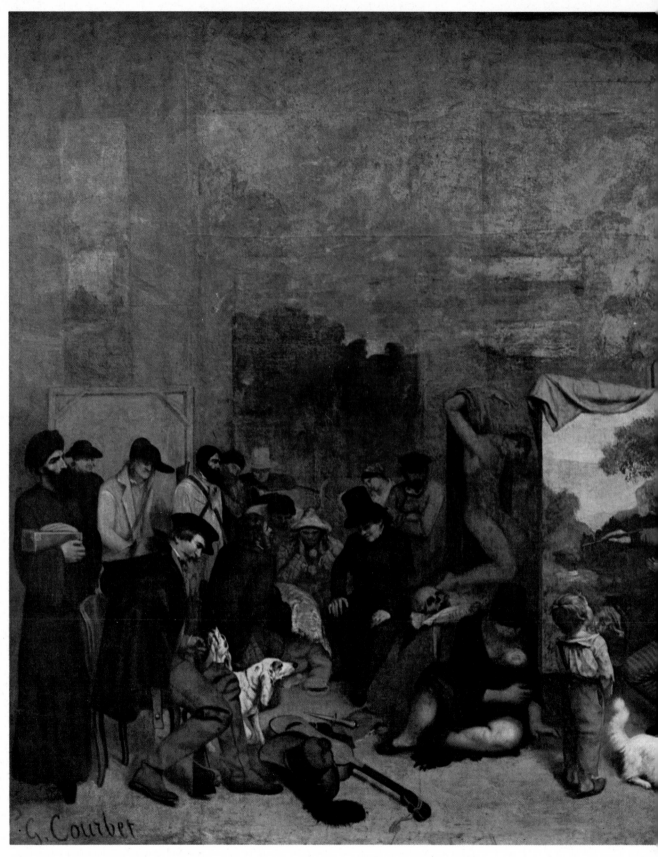

THE ARTIST'S STUDIO, 1854–1855. Oil on canvas, 142⅛″ × 235½″ (361 × 598 cm.)
Museum of the Petit-Palais, Paris

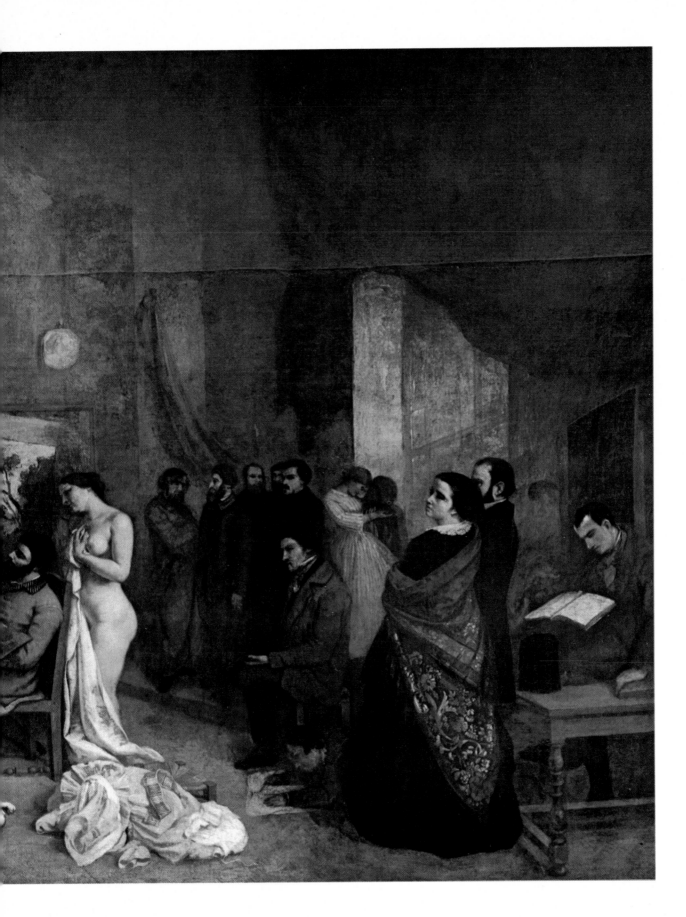

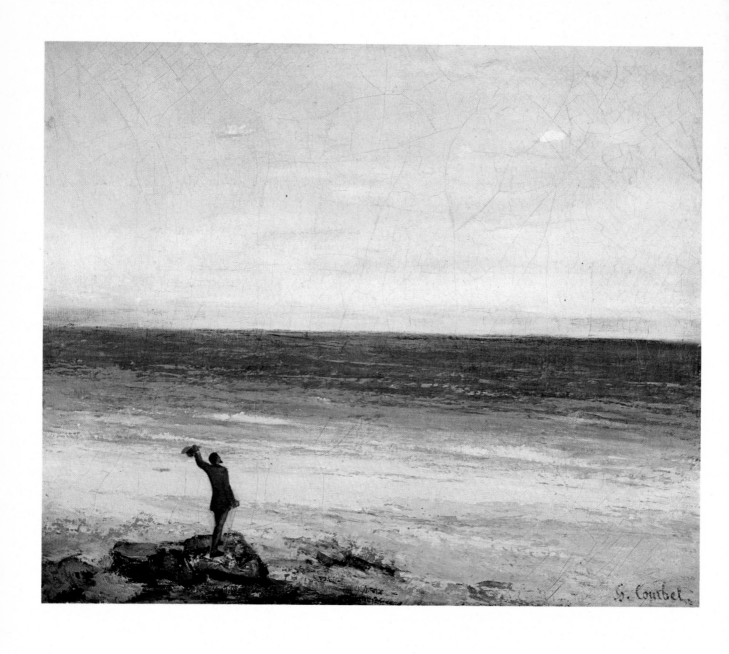

SEASIDE AT PALAVAS, dated 1854
Oil on canvas, 15⅜″ × 18⅛″ (39 × 46 cm.) Fabre Museum, Montpellier

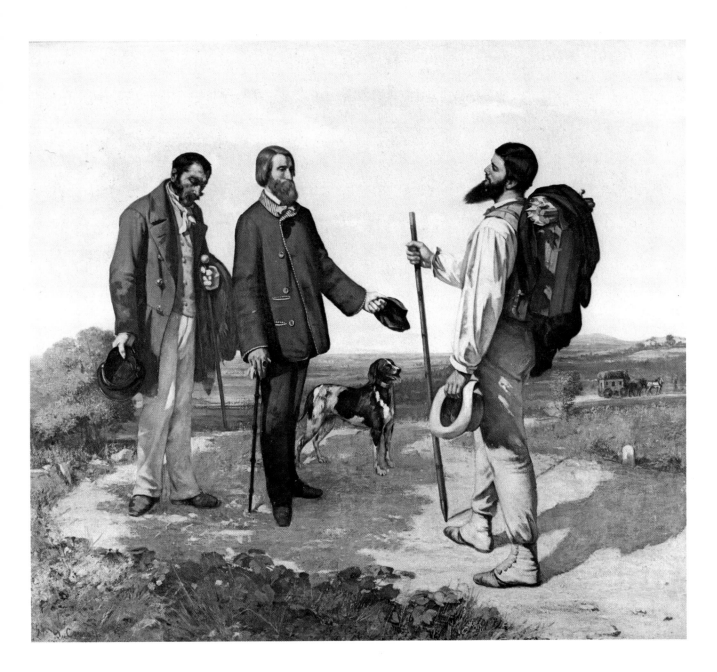

ment, was not interested, practically speaking, in the world of the machine and its effect on humanity. By comparison, the wheel of the spinning woman seems strangely archaic and appears to be inspired by the example of Ingres and the golden age rather than by contemporary social reality.

Urban life, the life of the workmen's quarters and the suburbs, the teeming movement which animated the Paris of Eugène Sue, Balzac and Victor Hugo, did not impress Courbet, either. There is, of course, an exception: *The Departure of the Fire Brigade,* which is dated 1850–1851 and was interrupted for political reasons after the overthrow of the government on December 2, in which Courbet depicted « firemen rushing through the Paris night to put out a blaze.» The work is enigmatic; the officer and his men appear to be going in different directions, in one case summoned by a common man, in the other by a common woman of the people, while a bourgeois couple turn away prudently. What does this divergence mean? To see in the worker, as the catalogue of 1977 suggests, Badinguet, that is to say Napoleon III, who in his youth had escaped from the fortress of Ham disguised as a workman and had written a book on the suppression of poverty, is more than hazardous. Was this would-be Napoleon proposing to the firemen that they should follow him in order to extinguish this social conflagration which had broken out in 1848? Why not but, then, why at all? In fact the already mysterious element of the painting is increased. On the other side of the picture fires flare curiously (unless they are indeed flames from the pumps themselves), as if disaster lay in wait everywhere and threatened all around them. Whether a simple urban night scene, a picturesque portrayal of an ordinary fire, or an evocation of the troubles and smoky dreams of 1848 (the fire lieutenant who served as technical advisor to Courbet was accused, after the coup d'Etat, of being an arsonist), the picture remains as mysterious as it is moving. So great is the dignity of the workers portrayed in it that one is forced to believe that it is the people who are really the heroes of the work.

The fallow period which followed the creation of this masterpiece is all the more regrettable when one considers the productiveness of Courbet's contemporaries. Carpeaux with dark strokes brought to life a *Ball in the Tuileries* (Louvre) in 1867, and *Attempted Assassination of Bérésowki* (Compiègne); Daumier produced his courtroom scenes, his interiors of thirdclass coaches, his laundresses; Doré, in 1872, described the wretched, swarming slums of Dickens' London; similarly Joseph Stevens, with his *Morning in Brussels* (1847, Museum of Brussels), with the stray dogs, the garbage, the poor wretches, produced one of the most honest and pitiable evocations of a nineteenth century city; Antigna with *The Fire* (1852, Orléans), which would not suffer from being hung alongside Courbet's *The Flood* (1856, Angers) belonged to the group of artists interested in « large popular scenes» praised by Champfleury; Bonvin, « one of the people, painter of the people,» did kitchen interiors or classroom scenes with coifed nuns and poor orphan girls which have a seriousness, an emotional quality, a restrained coloring which makes him akin to Courbet, although a Courbet in miniature; Tassaert painted victims of poverty like himself who inhabited tiny single rooms with dramatic emphasis; and there were many others of greater or less renown: Gustave Brion depicted life in Alsace; Adolphe Leleux did Breton scenes; Edmond Hédouin and Jules Breton wrote pages on peasant life which are not completely overshadowed even by the great image of Millet. A penchant for contemporary reality was truly demonstrated by a great many artists who took up a good deal of the space in the Salons and who by no means confined themselves to anecdotal reporting or elegant affectation, a fact which should be clearly understood. Courbet's originality (and what made him sensational) lay not in his choice of subjects, but in the style of his treatment of them, which was sober, pictorial, with a minimum of descriptive details. It was this concern for the basics which led him to return, or more exactly to go, to the most traditional subjects (nudes, for instance, and still lives), where his genius for getting to the root of things artistically could have full sway.

It is not a question of underestimating or making light of Courbet's convictions, which would be absurd, but the problem of Proud'hon, who at any cost and even at the risk of being ridiculed wanted to try to see in Courbet's paintings a statement illustrating what is exactly the wrong road to travel. Thus he would have the spinner sleeping as a result of exhaustion: « Every day she arises at the crack of dawn and is the last to go to bed; chore is piled upon chore and she has to work hard and ceaselessly: » Can one take stock in the analysis of Proud'hon or that of Champfleury, who saw in the sleeping woman « only a large and lazy soul made drowsy by the heat . . . a member of the proletariat who ate three square meals a day »? Proud'hon even went so far as to insist that the buttocks of the woman bathing were the symbol, the actual image of « the obese bourgeoisie, deformed by fat and luxury, in whom any idealism is smothered under soft layers of flesh, and who is doomed to die of cowardice if not of melted blubber; there she is, as she has been formed by her stupidity, her egotism and her cooking. . . .» As to the presumed husband of the nude, « a liberal under Louis-Philippe, a reactionary during the Republican regime, he is

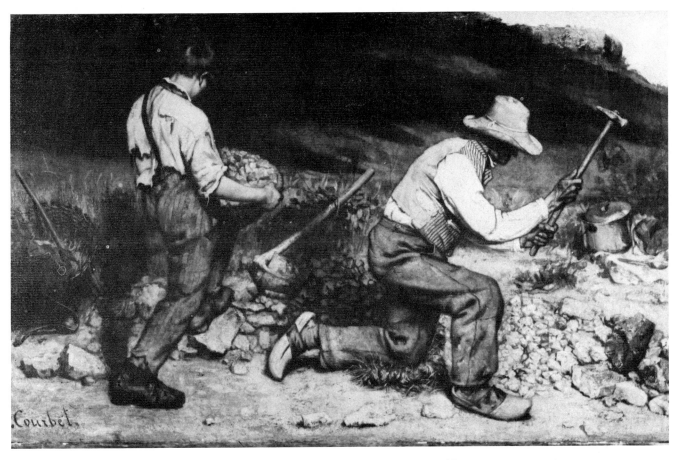

The Stone Breakers, Salon of 1850–1851. 50¾″ × 58⅝″ (129 × 149 cm.)
Oil painting destroyed during bombing of Dresden Museum

actually one of the most loyal subjects of the Emperor.» Everyone knows there is nothing simpler than to speak for mutes or, better still, for people who are absent!

At least twice Courbet let himself be caught in the trap set by Proud'hon of painting with a message. *Coming back from the Lecture* (see p. 59) (1863) was unfortunately destroyed by an owner concerned about the reputation of the Church. It was similar to what happened to *Le Peletier of Saint-Fargeau* by David, ransomed and destroyed by the daughter of that member of the French Revolutionary Convention who wanted to erase even the memory of what she thought to have been her father's shameful deed. It is difficult today, simply on the basis of an engraving and a small replica, truly to comprehend the real quality of the immense canvas, undertaken by Courbet during a stay in Saintes. «The picture is critical and also very, very comical,» Courbet wrote his father. Some parsons were shown coming back from a conference or a meeting where the priests of the diocese which included Ornans took turns bringing them together. This gave them an opportunity to discuss the problems of the parish and, above all, to enjoy good food and drink. Ever since Tartuffe's time, it has been clear that because someone professes to be devout, he is no less a man. Courbet depicts them in various states of intoxication, reeling and keeping on their feet with more or less difficulty. A statuette of the Virgin placed in the hollow of a tree contemplates the scene without protest. A peasant, a freethinker, laughs at the spectacle, which reinforces his skepticism, while his wife, as Castagnary comments, «ever pious, observes her religion and kneels to pray.» It is easy to guess what descriptive comments could be inspired by the subject matter. Everything could be explained. Courbet answered Castagnary, who asked him what the old parson beating the air with his cane was doing: «Can't you see? He is lunging at a heretic; he is striking a follower of Voltaire.» Proud'hon, in his book published

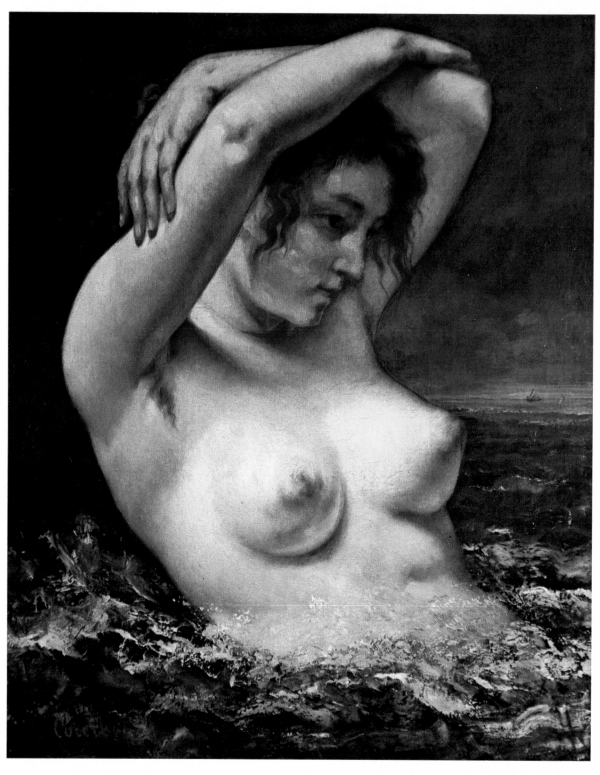

THE WOMAN IN THE WAVES, dated 1868. Oil on canvas, 25¾″ × 21¼″ (65,4 × 54 cm.)
The Metropolitan Museum of Art, New York. The H. O. Havemeyer Collection

posthumously in 1865: *On the Principles of Art and its Social Aims,* constantly iterated and reiterated what he deemed the philosophy of the case. «What Courbet wished to show us, in the manner of a true artist, was the total ineffectiveness of religious discipline, which is really the same as saying that idealistic thinking, failing to help the priest achieve the perfect virtue demanded of him and to demonstrate the moral perfection which is the goal of religion, of acts of faith and of those who contemplate a mystical ideal, can only ride for a fall and stumble to the ground.... Who can fail to see,» he continued, «that the idea for such a composition can only have occurred to the artist on the day on which art, for so long the slave of its dogmatic idealism, finally burst its chains ... *Coming back from the Lecture* is essentially a work of our time; either twenty-five years ago or twenty-five centuries ago, it would have been impossible.» Indeed! The motif of parsons behaving foolishly has been in vogue as a favorite topic of farce and satire eve since the founding of the Church.

Numerous painters can be found who, in the nineteenth century, coming out of similar environments, treated related subject matter. Daumier, of course, was one, but there were also other artists not suspected of being militantly anticlerical such as Claudius Jacquand, a painter of the pious School of Lyons, and Joseph Beaume who, while turning from one historical or religious scene to the other, would slip in an irreligious detail. The Homais (a character from *Madame Bovary* who personified bourgeois inanity) of the period also had their artists, not surprisingly. Thus during the Third Republic another unknown, Baron, would be a leading purveyor for prelates at home, in informal attire, sampling epicurean delights. In fact, this was one of the recognized specialties thought appropriate for genre painting, for the same reasons which justified the portrayal of musketeers or Louis XV balls. Although this picture was rejected by the judges of the Salon, the edge of its sensationalism has become blunted today. What strikes us is the unreality of the work, even if Courbet introduced a donkey into the studio of Port-Berteau and took as models the inhabitants of the hamlet and Father Faure (who as it happened was not a man of the cloth). «A colossal Breughel aborted in petty satire,» according to Focillon, *The Lecture* illustrated Courbet's difficulty in imagining and putting on canvas a complex composition (presumably he never actually met the disorderly conference members) when the aid of a vision such as the one which inspired *The Stone Breakers* was lacking; he was unable to push back the boundaries which circumscribed his genius, the genius of the prosaic.

The Beggar's Alms (see p. 56) (Salon of 1868) rendered a sort of posthumous homage to Proud'hon and his analyses and ended «the series of the open road» which, with *The Stone Breakers, Peasants of Flagey Returning from the Fair, Coming back from the Lecture* (and, of course, *Good Morning, Monsieur Courbet* (see p. 37) and even *Burial*), translated into detours on the road Courbet's successive encounters with life, men and ideas. An old tramp finds someone poorer than he and gives all that he has to a little Gypsy. The incident is instructive and verifies Kropotkin's theories on the solidarity of the poor, but «this comic-opera rag picker,» to use the expression of André Fermigier, with his Robert Macaire opera hat (Macaire was a fictional crook), seems almost too natural to be true. From Jules Laurens and, for example, in the etching of *Country Vagabonds* (1865) we can obtain a more precise and accurate description of the population which wandered across the French countryside in that period. «He has been deformed by age and made gaunt by deprivation; his skin, under which jut his dry bones, has wrinkled in the sun.... A knight of the road, he has taken on the color of the road.» This observation, which could have been made by Proud'hon, is a quotation from Castagnary, who replaced Champfleury, disappointed and reserved, in the role of manager and defender and, under the label of Naturalism, raised anew the banner of Realism. Today we are a little irritated precisely because the picture has something of the quality of a suburban Countess de Ségur (author of sentimental children's books), yet this sentimentality is overshadowed by the truthfulness inherent in the child, the dog and the Gypsy; by the manner in which any suggestion of pathos is offset by the honesty of the landscape. Courbet never is completely weak and mawkish, for the painter invariably retains the upper hand.

But, once more, the preference we may feel for one or the other particular aspect of the picture does not make any sense unless it is an acknowledgement of the taste and sensitivity of art connoisseurs at a given period. Courbet's work forms a single entity, which may be analyzed but not broken down into its details. In spite of its apparent simplicity, it has an obscure and unresolved side which, in effect, explains its actual complexity. Thus *The Artist's Studio,* to come back to this 1855 canvas, remains a picture as difficult to read as the apparently simplistic manifesto in the catalogue of the one-man show. However, in a letter to Champfleury written in January 1855, Courbet defined his goals: «The first part gives the physical and moral story of my studio; they are people who live on life, who live on death. It

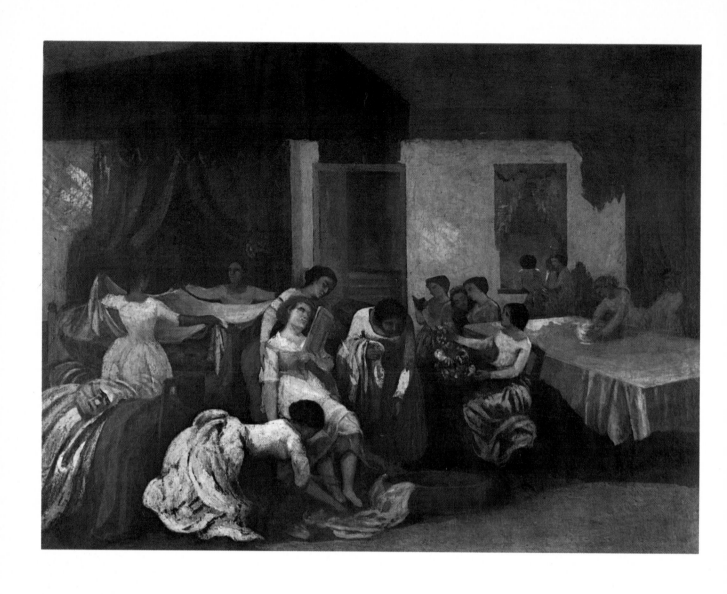

The Preparation of the Dead Maiden, 1865
(Around 1919, the picture was altered and became The Preparation of the Bride)
Oil on canvas, 74″ × 99″ (188 × 251 cm.) Smith College Museum of Art, Northampton, Mass.

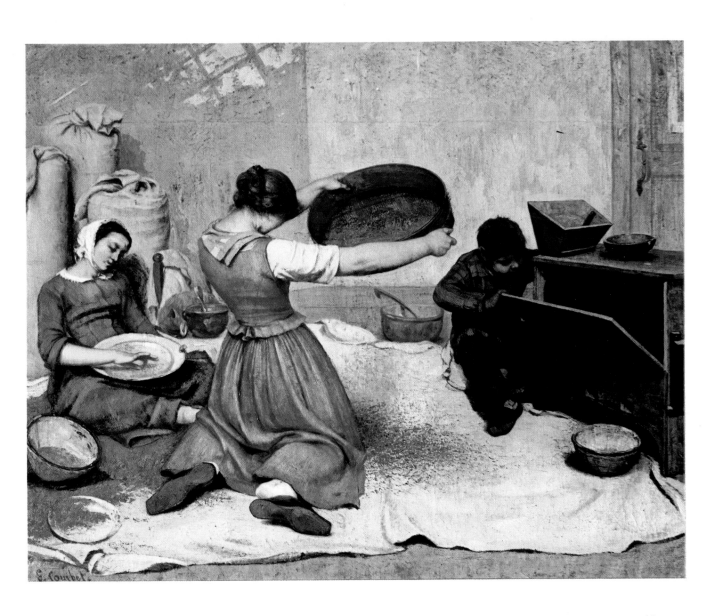

Study for the «Young Women on the Banks of the Seine», 1856
Grease pencil on wood blocks, 17½" × 21" (44,5 × 53,3 cm.)
Collection: Mr. and Mrs. James W. Alsdorf, Chicago, Ill.

is Society in its upper echelons, in its lower ones, in the middle stratum.» To the right, then, are «the friends, the workers, the connoisseurs of the art world.» From left to right, starting in the foreground, one can therefore recognize Promayet, Bruyas, Proud'hon, Cuénot, Buchon, Champfleury seated, an art lover and his wife, Baudelaire and his mistress, later rubbed out, the black Jeanne Duval. To the left is «the other world, the world of the commonplace, the people, wretchedness, poverty, wealth, the exploited and the exploiters, the people who thrive on death.» Courbet successively gave the names (reading from left to rights) of a «Jew I saw in England» (it is not certain that he ever went there), a «parson with a triumphant expression on his bloated red face, a poor pock-marked old man, a former Republican of

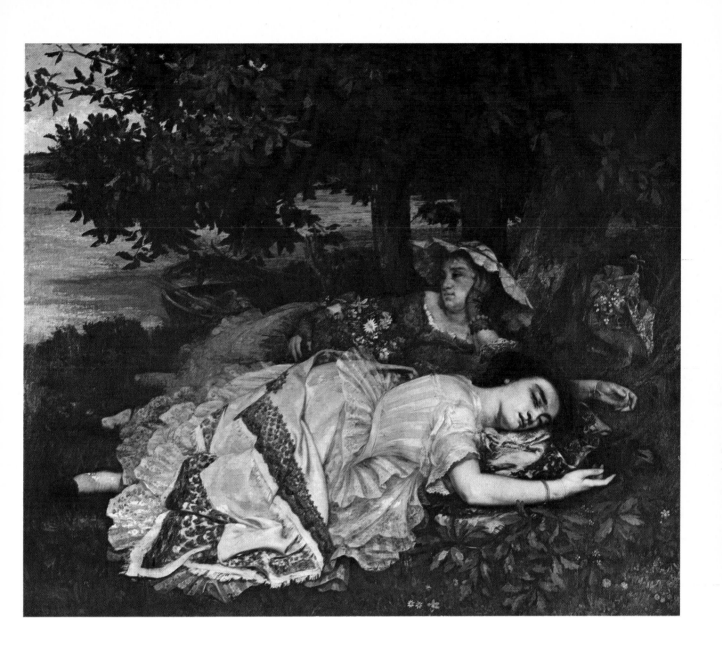

YOUNG WOMEN ON THE BANKS OF THE SEINE, Salon of 1857
Oil on canvas, 68½″ × 78¾″ (174 × 200 cm.) Museum of the Petit-Palais, Paris

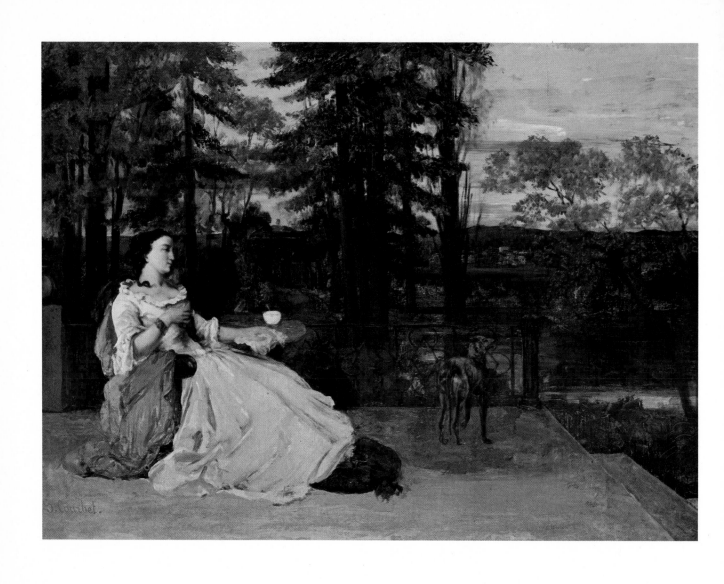

THE LADY OF FRANKFURT, 1858–1859
Oil on canvas, 42″ × 55⅛″ (104 × 140 cm.) Wallraf-Richartz Museum and Museum Ludwig, Cologne

46

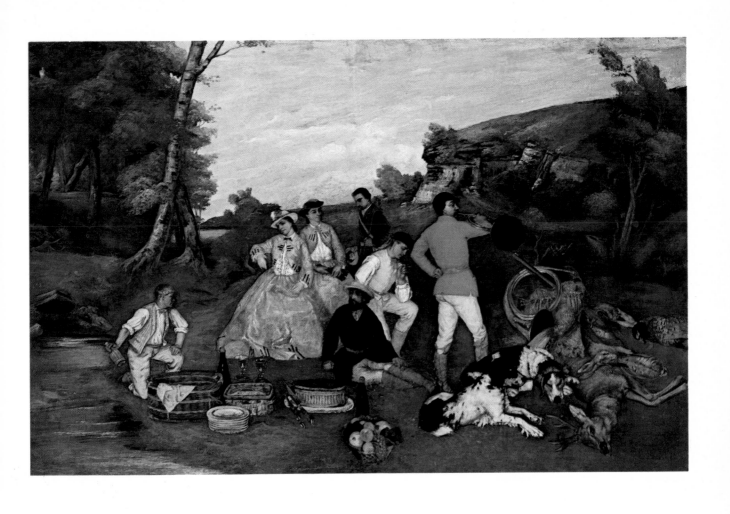

THE HUNTSMEN'S PICNIC, 1858–1859
Oil on canvas, 81½″ × 127⅞″ (207 × 325 cm.) Wallraf-Richartz Museum and Museum Ludwig, Cologne

47

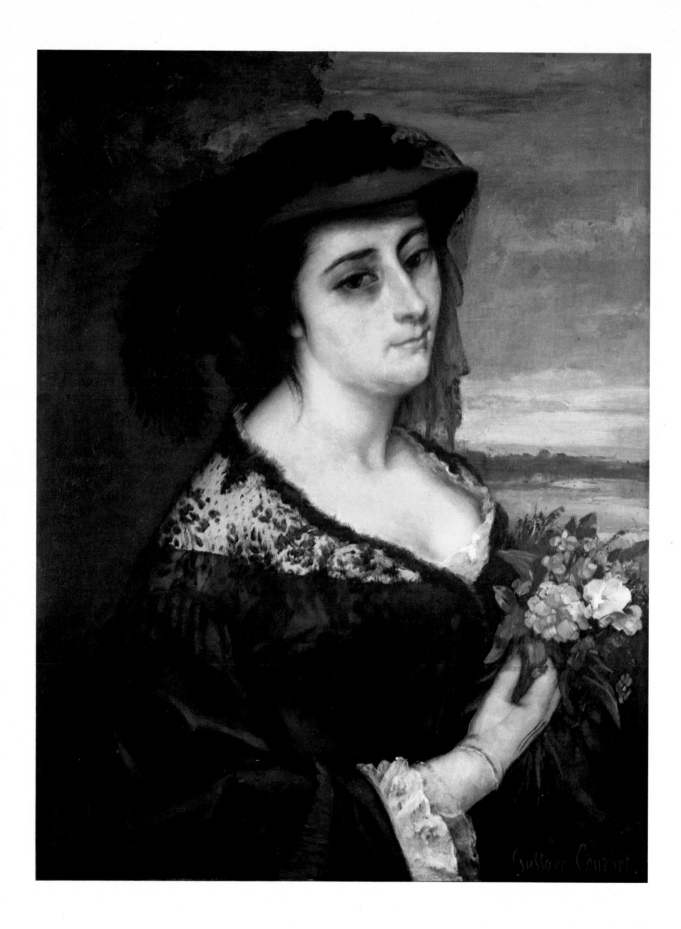

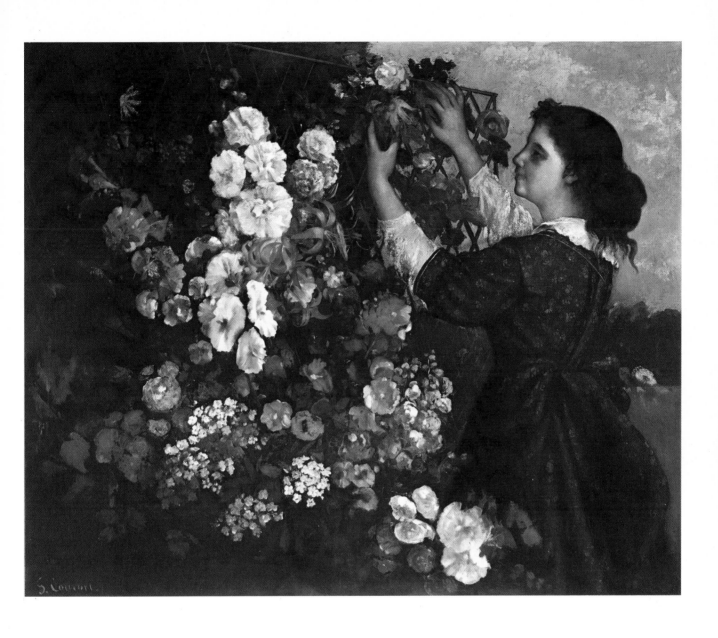

MADAME BORREAU, dated 1863
Oil on canvas, 31⅞″ × 24⅜″ (81 × 59,4 cm.)
The Cleveland Museum of Art. Leonard C.
Hanna, Jr. Bequest

THE TRELLIS, 1862
Oil on canvas, 43¼″ × 53¼″ (109,8 × 135,2 cm.)
The Toledo Museum of Art, Ohio. Gift of
Edward Drummond Libbey

49

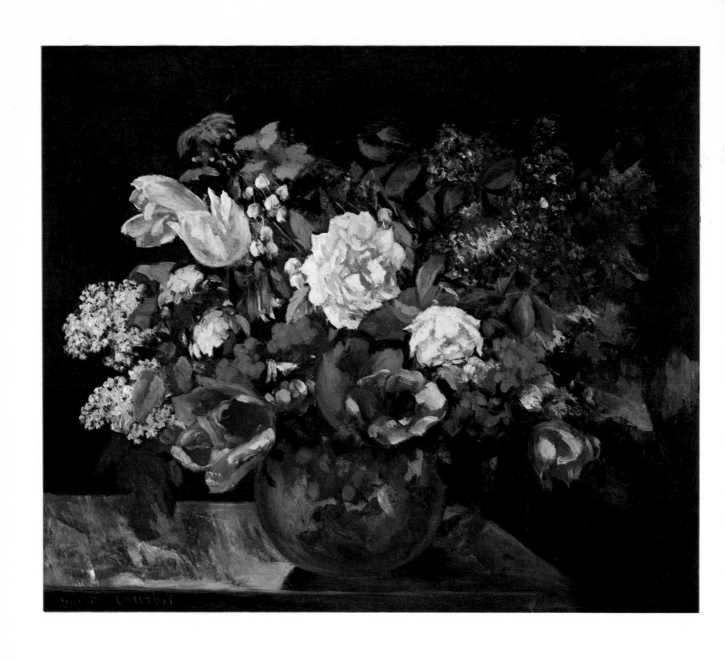

Flowers, 1862–1863
Oil on canvas, 20$^1/_{16}''$ × 24$^3/_8''$ (51 × 62 cm.) Private collection, Zurich

50

FLOWERS IN A BASKET, 1862–1863
Oil on canvas, 29⅛″ × 39⅜″ (74 × 100 cm.) Glasgow Art Gallery

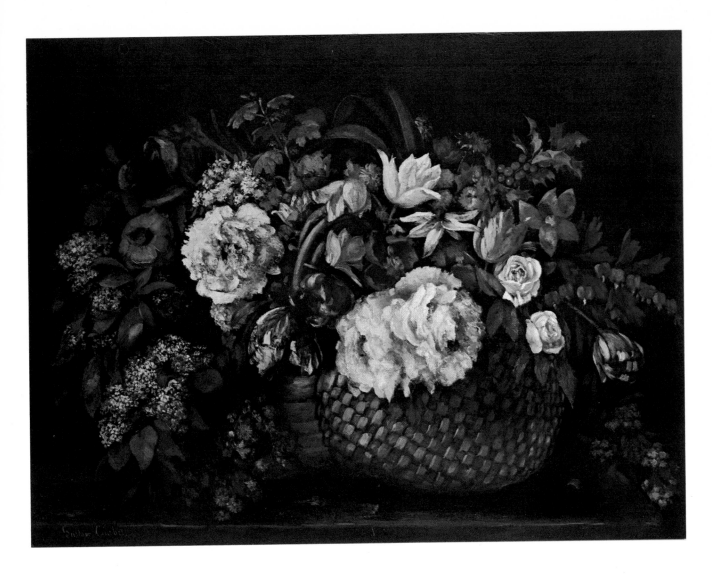

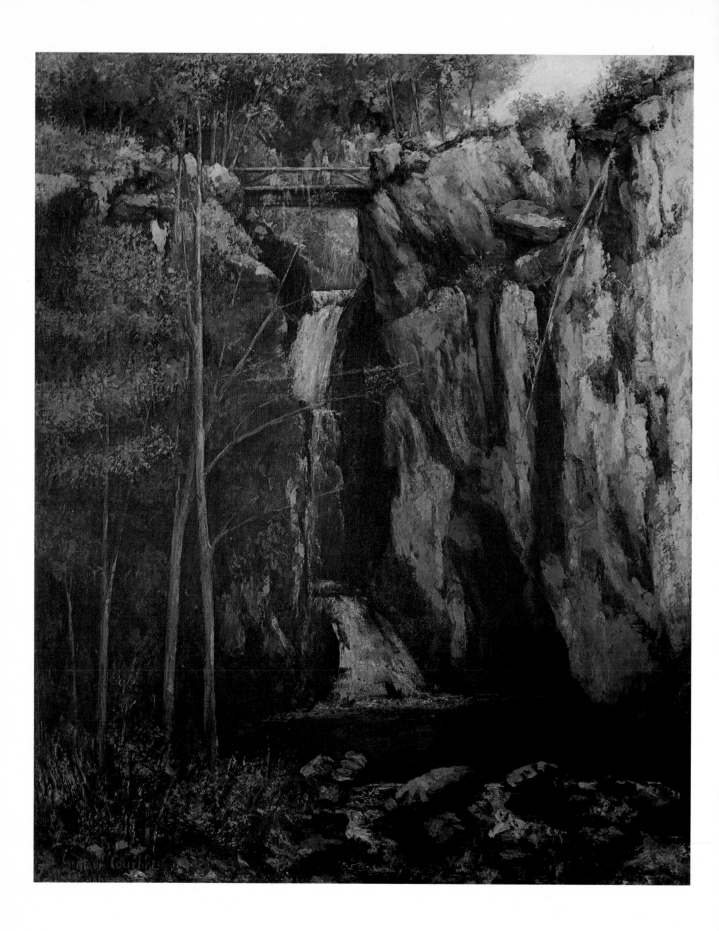

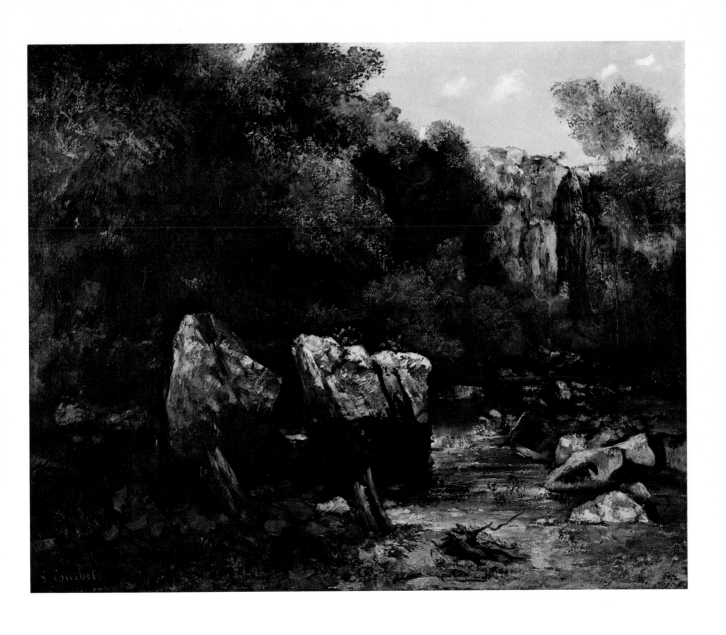

Waterfall at Conches, dated 1864
Oil on canvas, 28¾″ × 23¼″ (73 × 59 cm.)
Museum of Beaux-Arts, Besançon

Gorge in a Forest (The Black Pit), around 1865
Oil on canvas, 26¼″ × 32⅜″ (56,5 × 82,3 cm.)
Collection: Acquavella Galleries, Inc., New York

53

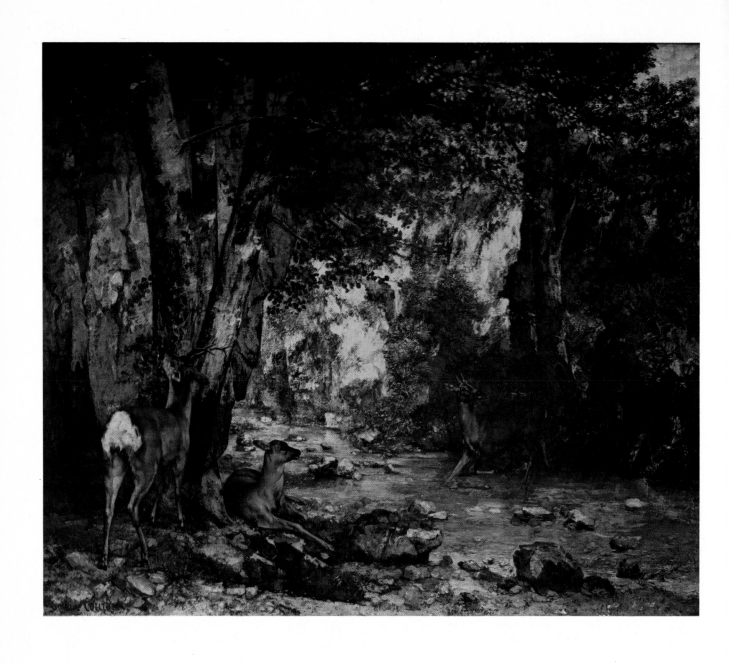

COVERT OF THE ROE-DEER AT THE BROOK OF PLAISIR-FONTAINE, Salon of 1866
Oil on canvas, 68½″ × 82½″ (174 × 209 cm.) Louvre Museum, Paris

54

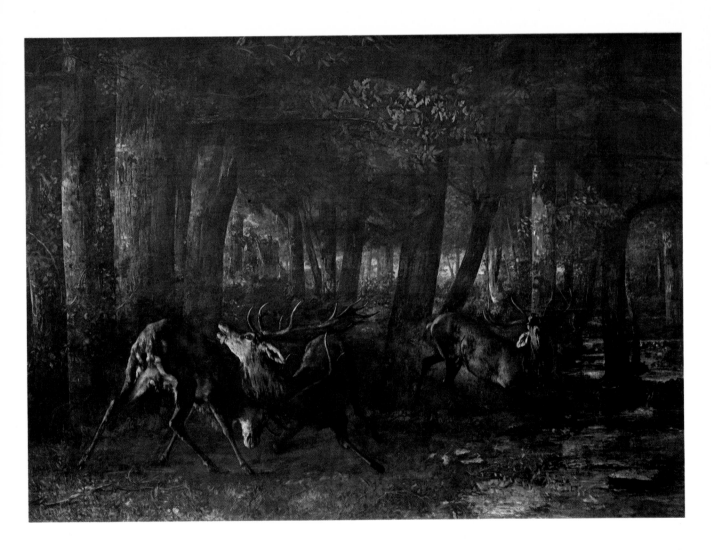

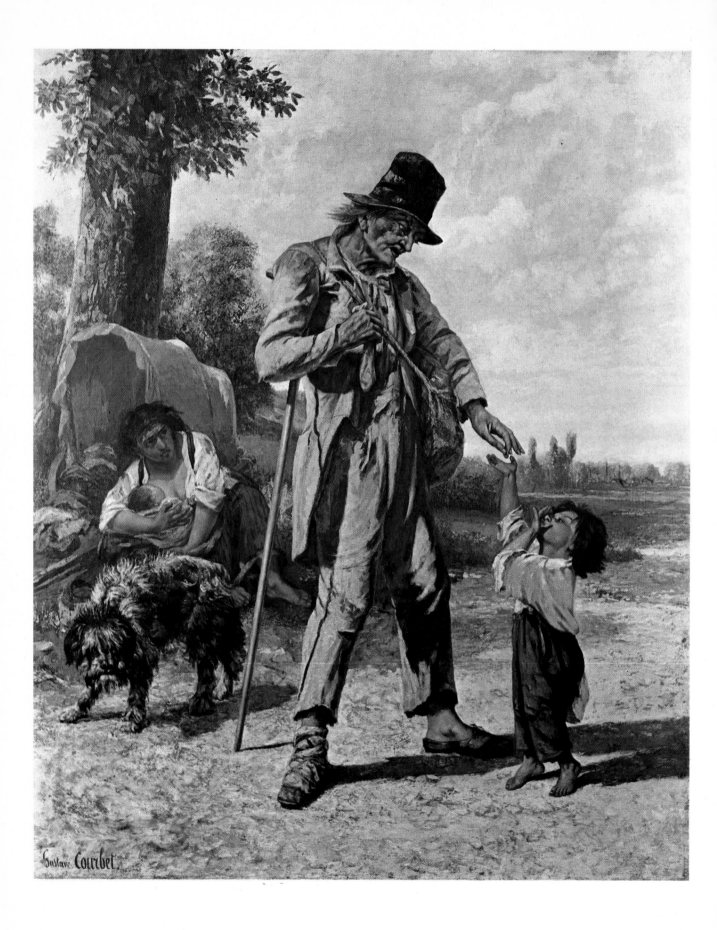

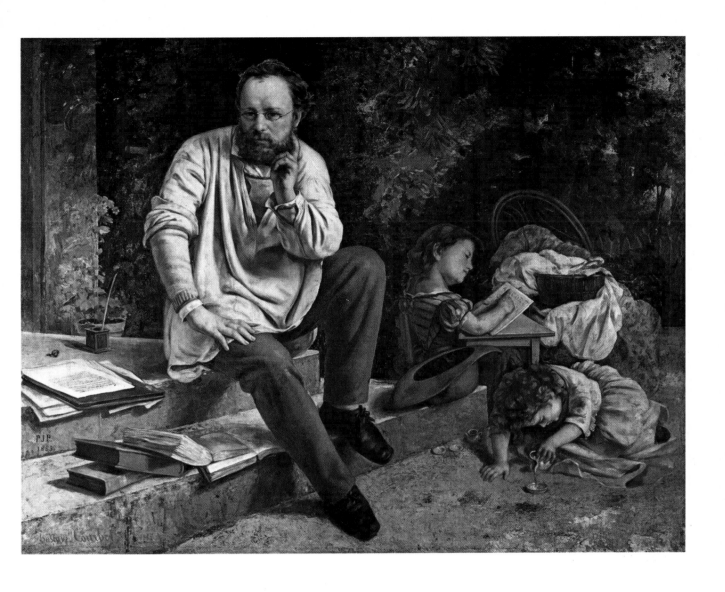

BEGGAR'S ALMS AT ORNANS, Salon of 1868
◁ Oil on canvas, 83″ × 69″ (210 × 175 cm.)
Glasgow Art Gallery. The Burrell Collection

PROUD'HON AND HIS FAMILY, Salon of 1865
Oil on canvas, 57⅞″ × 78″ (147 × 198 cm.)
Museum of the Petit-Palais, Paris

1973 . . . a hunter, a mower, a strong man, a bewigged circus clown, a seller of braided uniforms, a worker's wife, a worker, an undertaker's assistant, a nursing Irish mother. . . .» On the basis of this letter, which is explicit yet teeming with obscure references, certain allegorical interpretations have been made, according to which Champfleury is represented as Prose, Baudelaire as Poetry, Proud'hon as Philosophy, etc. But this explanation is so imprecise, so inadequate that it becomes absolutely imperative to seek further. Hélène Toussaint boldly attempted to do just this. If these are portraits, why are there blank spaces, and why does the left side not contain any?

With a somewhat startling dossier, Hélène Toussaint undertook the development of arguments supporting new identifications. To the left the Jew was said to be Achille Fould, banker, finance minister, bringing in his money box the funds needed to overthrow the government; the parson was Louis Veuillot, the ultra-Catholic journalist; the old man of '93 Lazare Carnot, who served under so many administrations; the hunter, according to this theory, had the features of Garibaldi, the man with the cap those of Kossuth, the mower those of the Pole, Kosciuszko; the clothes merchant resembled Persigny, offering his wares to Turkey and China (1855 was the year of the Crimean War, and since 1849 France had had a concession in Shanghai); the worker had the features of Herzen, the understaker's assistant those of the journalist Emile de Girardin — and did the man in the foreground not resemble Napoleon III, the poacher of the Republic? To the right, the two art lovers would be the banker Mosselman with Madame Sabatier, the famous «Présidente» of whom Baudelaire dreamed and who, ironically, turns her back on him. Why not? Some resemblances are troubling. But there are certain faces which seen to belong to a period and after a hundred years, everyone has the tendency to look alike. Consider, for example, those eighteenth century portraits of women who are all Madame de Sevigné, or if the nose is a little long, Queen Christine of Sweden. Why could not Napoleon III, for example, just as well be Morny, who was, in effect, Courbet's patron? Besides the identifications based on the play on words: a circus strongman to represent Turkey, because one says «as strong as a Turk,» are rather risky. Did the presence of the French in China have such a great importance with the public that Courbet should make a reference to it in a painting which was to evoke the problem of nationalism. Nothing is less certain. In fact the picture is only more obscured by such references. Curiously, it even appears favorable to the new regime in its evocation of nationalities and pauperism. A «real allegory» assuredly went beyond what could be anticipated from Courbet, who seems to have had difficulty mastering the implications of such a complex argument, which was inspired by goodness knows who. Should we see in it a Masonic picture, as Hélène Toussaint would have us believe? Thus the nude model and the dummy of Saint Sebastian could represent Man and Woman, the two columns of the Temple; the young boy would be the alchemic child, and *The Artist's Studio* would be the star or rather the Lodge. Before a proposal bolstered so meticulously, one must either agree or wonder, to dispel any lingering doubt, why such a revelation was so late in coming. How did it happen that no one before noticed or suspected the allusions, even though Courbet was constantly being discussed and so much testimony was accumulated? Was *The Artist's Studio,* then, a work so dangerous, so mysterious, that a conscious conspiracy of silence concealed its secrets, which were those of the new regime and the coup d'Etat, of European politics, of socialism, of Masonry? The unexpected was possible in the case of Courbet, whose peculiarities, ideas and the ties which bound him to the «customs and ideas» of the period are little known, so well did this demon of a man cover up his tracks.

LYRICISM

Courbet, a stubborn opponent of the administration, admirable in his loyalty to his Republican and socialist friends, was among the painters the most strongly acclimated to the mood of the Second Empire. This fact has frequently been observed, almost always to the detriment of the painter. In the preface to *Exhibition of the Works of Courbet* in 1882, Castagnary took note of this aspect of his evolution and attributed the responsibility for it to the lack of comprehension of the critics and the public. «What was the use of persisting? Courbet felt he would be wasting his energy and his youth. Without exactly abandoning humanity, he paid closer attention to the sky and the sea, verdure and snow, animals and flowers. From *The Bathers* of 1853, accused of being thick and filthy, he went to the elegant nudity of the Parisian.» The explanation given that he had in fact been won over by the administration or else was

catering to the whims of his clientele were either false or inadequate. During the years of the Second Empire, Courbet found a happiness in painting which was related to the pleasure of living in that period. The Realist yielded to those realities which he cherished the most: nature, women, feeling true happiness in describing the simple emotion engendered by a bunch of flowers, a landscape, animals surprised as they broke from cover. Baudelaire was not incorrect when he compared Ingres with Courbet; the two had different emotional drives, but both were inspired by a similar sensuality. According to Baudelaire, Courbet was a fanatic when it came to «nature which was external, positive and immediate,» but he demonstrated so much love and simplicity that he became poetic and could justifiably be suspected of the «Supernaturalism» which Baudelaire complained that he sought in vain in his work, and which is called poetry.

 Young Women on the Banks of the Seine (see p. 45) (Salon of 1857) was to Champfleury illustrative of the change in Courbet. «Our friend has lost his way. He has tried too hard to feel the

Coming back from the Lecture, 1862–1863. Oil on canvas, 28¾" × 36¼" (73 × 92 cm.)
Kunstmuseum, Basel. Replica (?) of a painting of 1862, destroyed

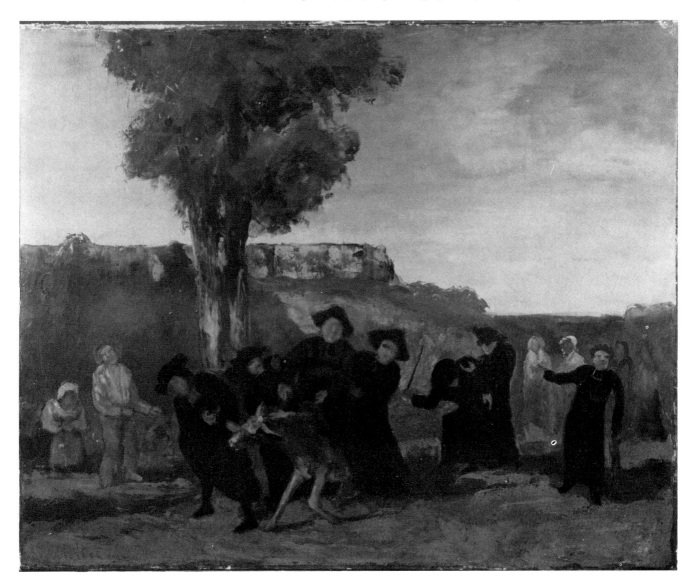

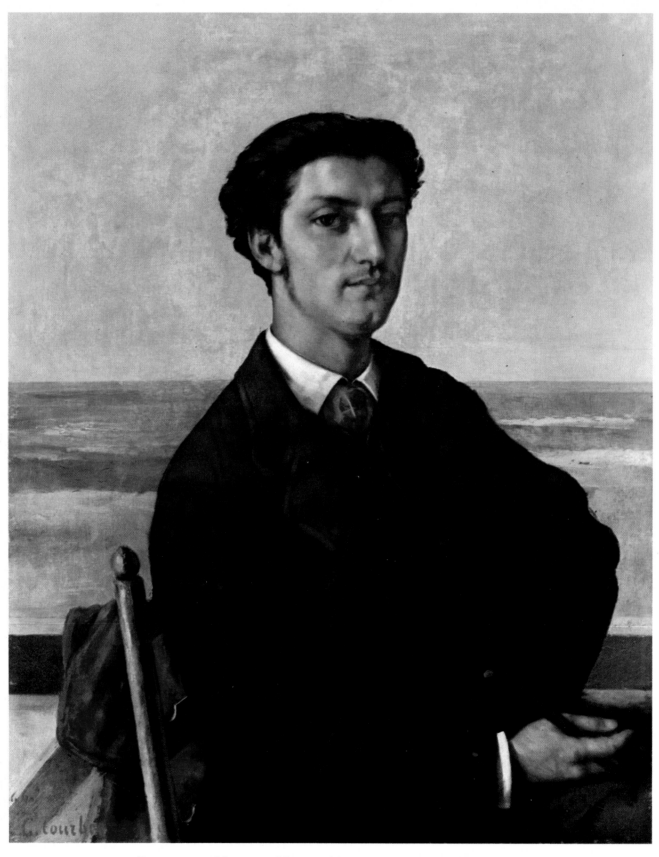

PORTRAIT OF MONSIEUR NODLER, THE ELDER, AT TROUVILLE, 1865
Oil on canvas, 36¼″ × 28¾″ (92 × 73 cm.) Smith College Museum of Art, Northampton, Mass.

pulse of public acceptance. He now aims to please.» According to Théophile Gautier, he was beating «hammer and tongs on the gong of publicity in order to capture the attention of the indifferent crowd.» The two young ladies lounging on the banks of the Seine near Bougival after eating are certainly not the department store employees described later by Zola, who on a Sunday afternoon set out to discover the wholesome pleasures of canoeing; Proud'hon was not deceived. «They are neither wives nor widows, that is clear at first blush; they are not even engaged, possibly through their own fault.» The brunette is a Phaedra dreaming of Hippolytus. «If you value your dignity as a man, flee, if you do not wish this Circe to turn you into a beast.» The blonde, ambitious and capable, is waiting, always according to Proud'hon, to meet «a lord, a Russian prince, a Spanish grandee or a stockbroker.» Therefore it is a social picture, in the same category as *The Stone Breakers*, showing the wretchedness, which in this instance is moral and not material, of a doomed society. So be it. But if the two friends, simply overcome by the heat, are merely daydreaming or even not thinking of anything at all ... there would still remain what is basic to the painting: two women lying in a landscape. It is true that they are wearing modern clothes and have somewhat commonplace figures, but one should not be misled by appearances. Realism is not equivalent to Verism. »The mass of material out of which stick arms and heads,» which was the way Gautier saw it, is admirably organized, in an almond-shaped composition worthy of Chassériau. Elegance and liaisons, all of the academic baggage at which Courbet turned up his nose, were lacking, but the arabesque of the fingers, the folds of the dress are, in their way, deserving of comparison with Ingres. Naturally, it is impossible not to think of the future picnics on the grass of Manet (1863) and Monet, although one runs a risk in finding too close a relationship: the risk of comparing the works according to the degree of clarity and brightness; *Young Women on the Banks of the Seine* is neither pre-impressionist nor impressionist. Begun in Ornans in 1856 (therefore very far from Asnières and Bougival), following numerous preliminary studies, *Young Women* cannot be listed in the category of paintings done in the outdoors (as a matter of fact, Manet habitually worked in a studio); even if the two women appear to be posed in the landscape, the pictorial unity is such that this type of question makes no sense. In the painting Courbet rediscovered the major concerns which had preoccupied the minds of Western artists since Titian.

Venus and Psyche or *Venus Jealously Pursuing Psyche or The Awakening* (1864) has disappeared since the last World War. Even though rejected by the Salon, the work showed that Courbet, beyond any doubt, was taking his place among the painters who today would be classified as official. The subject was drawn from mythology and therefore was incompatible with the fundamental principle of Realism, which was to select contemporary subjects. Venus pulls back a curtain and contemplates a sleeping Psyche. We know that in Montpellier in 1857 Courbet copied an old painting (about which unfortunately we know nothing) on the same subject. The treatment of the draperies, the arabesque of the figures prove that Courbet had adopted in their totality the major rules and regulations of decorative painting if not the art of the Fontainebleau school. The picture of Berne (see p. 67) (1866), which to a large extent uses the same type of subject and composition, centered on the torsos of two women, enables us to see very clearly the breadth of his treatment, the play of the flesh of the brunette and the blonde. Draperies, mats, the globes of the breasts, all of the components of the picture contribute equally to the colorful artistic lyricism. Was it the implications of the subject which caused it to be rejected in 1864? Proud'hon and Castagnary were categorical. «The residents of Ornans undoubtedly saw in it two women who, because of the heat wave, took off their nightgowns so as to be more comfortable ... others took them for bathers. One must be informed about current developments to understand the artist. One must have read Georges Sand (Lélia) and Théophile Gautier (Mademoiselle de Maupin); one must be familiar with the hypocrisy of our age in regard to lewdness....» Thus the picture depicted a Lesbian liaison, a subject which, as it happened, played an important role in the literature of the period. From Balzac to Henry Monnier to Baudelaire, Lesbos was an island which was very frequently described. But the nudes of Courbet, as was so accurately stated by Millet in a letter written in April 1864, have a different aura from those of Cabanel or even Baudry. The secret pleasures of Venus and Psyche cannot make us oblivious to the simple pleasure of looking at nudes and enjoying fine painting. Yet the general public may be deceived, perhaps understandably.

With *The Sleepers* (see the cover) in 1866, his intention becomes transparently clear, yet one should not be led astray and see in every one of Courbet's canvases portraying two women (in that case, why not *The Bathers?*) allusions to Sappho! The picture had been ordered by Khalil-Bey, a curious character who had held various diplomatic functions, was a great collector of erotic paintings, but also of good art: it was he who acquired the *Turkish Bath* by Ingres after, at the urging of his wife, Prince

Napoleon returned it to the artist. This same Khalil-Bey ordered from Courbet *Origin of the World* or, according to a description given by Maxime du Camp, «a nude woman, seen from the front, extraordinarily moved and convulsed . . . but, through an unbelievable oversight, the artist failed to paint the feet, the legs, the thighs, the belly, the hips, the chest, the hands, the arms, the shoulders, the neck and the head. . . .» The work, shown behind a curtain and the outer surface of which, like a retable, representing a snowy landscape, remained in the secret recesses of connoisseurs' cabinets. «Before this canvas, I feel compelled to apologize to Courbet: the woman's belly is as beautiful as the flesh painted by a Correggio,» Edmond de Goncourt wrote in his *Journal* on June 29, 1885.

Open to public view since 1953, *The Sleepers* today seem less like a scandalous portrayal of violent passion (Courbet is not Pascin) than like an exceedingly vibrant and shimmering paean to the beauty of the female body. The harmony of blue, pink and white is identical to the colors used by Boucher in his callipygian portrait of the so-called Miss O'Murphy. Alongside the *Olympia* of Manet (1863), which is more abstract, *The Sleepers* is striking because of the manner in which Courbet lifts a prosaic treatment to the level of the sublime. The weight of the blue material (compared with the greenish brown of Manet's geometric background), the scintillating quality of the still life, the slanting, slipping movement of the sleepers, all combine to create an impression of jubilation and sensuality and love for the work which make Courbet a worthy rival of Titian.

«If they are not happy this year, it will be proof that they are difficult,» Courbet said to a friend to whom he was showing *The Woman with a Parrot,* which he sent to the Salon in 1866, along with *The Covert of the Roe-Deer* (see p. 54). *They* (the government, the Academy, the public, etc.) were so happy that the bacchante almost effected a reconciliation between Courbet and the administration. Courbet thought it was agreed that the state would purchase *The Woman with a Parrot;* Nieuwerkerque, the superintendent of the Beaux-Arts, with whom he had crossed swords in 1855, had promised to buy it from the artist for 10,000 francs. «*They* are overcome,» Courbet wrote to his friend Cuénot. «All the painters and all the painting world are turned topsy-turvy. . . . Without any question, I am the outstanding success of the exhibition. There is talk of giving me the Medal of Honor, the cross of the Legion of Honor.» Alas! The state finally bought only *The Covered Stream.* Courbet spread the word of his indignation to the four winds, announced that he was going to publish what we today would call a white paper about the matter and predicted «that they are not going to last more than two years longer,» a statement which, after all, was at least half correct. Whoever was at fault, and undoubtedly the blame should have been shared, it is regrettable that an opportunity was missed, particularly regrettable for the rooms of the Louvre. Repeating a number of the features of *Venus and Psyche* of 1864 (the column of the torso, the draperies and even the parrot added as an accessory for Psyche, at the request of the buyer), *The Woman with a Parrot* is certainly the most elaborate and complex of Courbet's nudes. The hair spreads out with magnificent richness. The skirt in the foreground (a realistic detail, since Courbet's female nudes were, to use an expression of Thoré-Burger, primarily women who had undressed), seems to have been thrown there hurriedly although, as if by chance, the outline of the border subtly duplicates the oval of the body. Castagnary dreamed about the parrot. «Is it not a type of new and deliberate caricature of the Annunciation to the Virgin in which, instead of the Holy Spirit in the form of a dove, stupidity takes shape in the form of the parrot!» Whether it was satirical or not, whether or not it deserves the new appelation of naturalistic (to Castagnary, the term meant the addition of a conceptual element to the interpretation of reality), the picture bears impressive witness to Courbet's lyricism. «When before had anyone painted like that in France? What would have been the judgment of the Great Renaissance itself on such a work?» Ladies of doubtful virtue, sprawled on a Parisian bed, or heroic nudes which rightfully bring to mind a Correggio or a Velasquez, the nudes of Courbet, such as the lofty *Bather* of 1868, breasts emerging triumphantly from the sea, clearly proclaim his love for both physical and painted beauty (see p. 40).

Any surprises engendered by Courbet's works, ranging from his parrot to his nudes, are only relative for keen observers. From the beginning — this has been sufficiently emphasized and joked about — the self-portraits of Courbet testify to his ability to idealize. An «Assyrian» profile, in every respect worthy of being offered as a model for studios, and a strong tendency to be self-satisfied and possibly even narcissistic may suffice to explain his liking for self-portraits and the number of them which he executed, but not the lyricism which animates them. The self-portrait known as *Self-Portrait with Black Dog* (1842), which earned him the honor of having a picture shown for the first time in the Salon in 1844, shows a masterful touch and a subtlety in the composition and a treatment of color which indicate convincingly how great was the painter's virtuosity even at the beginning of his career. In comparison to such works,

Valley of Lauterbrunn, undated. Graphite, $3^{15}/_{16}'' \times 5^3/_8''$ (10 × 13,6 cm.) Louvre Museum, Paris

After Dinner (1849) and *The Stone Breakers* (1849–1850), in spite of their apparent naïveté, appear really sophisticated: a simplicity acquired through study and effort. In *Self-Portrait with Black Dog,* the triangle outlined by the stick and the dog, the delicacy of the contours, which give the ear of the spaniel the configuration of an odalisk, and the similarities between the massed shapes of the group and the rocks demonstrate to what extent the painting has been planned and organized. This is what makes the elegant profiles of the dog and his master, the naturalness of their attitudes and the quizzical, almost questioning expressions on their faces actually moving.

Lovers in the Country - Youthful Emotions is perhaps the most popular of Courbet's compositions. The man and the woman, seen from profile, hand in hand, their gaze seemingly turned inward upon themselves and their hopes for the future, have become for a very large segment of the public one of the most familiar representations of the joy of love. «Lovers, happy lovers, may you create for one another an eternally beautiful world....» Is this a paradox? The Realist Courbet, like Millet in *The Angelus,* was one of the painters who were best able to express a certain romantic sensitivity and to imbue their art with poetic feeling. He is as much a lyrical artist as Delacroix. He knew how, with these profiles, to strike a medal giving the two faces of the love of Her and Him. If one believes, as Miss de Forges did after studying a radiograph of the picture, that the *Wounded Man* (see pp. 6, 10) was a victim of the cruelty and disappointments of love, then Courbet, like another Musset describing the cycle of Love, had known and was depicting, in the two successive portraits, the transition from a night in May to the mortal darkness of December. A radiographic examination of the picture showed that the original composition included a woman. The drawing of Besançon, *Siesta* (see p. 29) is roughly equivalent to this version. Thus, from the years 1844–1845 to 1851–1854 (the date given for the picture) the change which took place, if it depended as much on the individual evolution of the artist as it did on considerations of an artistic order, was his way of interpreting the experience of man, in turn alive and discovering love and being struck by sorrow. We know very little about Courbet's private life, the details of which his sister Juliette religiously and unfortunately suppressed. We are aware that Courbet went through a critical and painful period in 1851. Virginie Binet, by whom he had had a child, left him, taking their son with her. Perhaps the *Wounded Man* was really a portrayal of Courbet, hiding behind his smiling mask, as he wrote his friend Bruyas in 1854: «a grief, a bitterness and a sadness which sucked at my heart like a vampire.» Whatever the facts may be, and we should be careful not to romanticize and picture Courbet as the hero of a soap opera, it is indisputable that his portraits reflect one of the constants of lyric inspiration in its purest form: talking about oneself so as to be able to speak about others better.

Furthermore, there is surely a dark Courbet whom the *bon vivant* of beerhalls, the fancier of solid reality should not cause us to forget. The *Preparation of the Bride* (see p. 42), if indeed the subject, as Hélène Toussaint correctly supposed, is the *preparation of a dead maiden* and bears a relation to the mysterious *meal of the dead maiden* mentioned as being among his works, is a tragic and fantastic picture, for which we maintain a later date, after 1860. In a blue-white light, women are dressing the young woman for her imminent and definitive nuptials, the ceremony of death, so often present in Courbet's work, from *Burial at Ornans* to *Stag at Bay.*

The Meeting, 1854, on the other hand, gleams with all the optimism of an artist at the height of life's noontide. The picture was immediately successful. The subject caused people to smile: a meeting of the painter with his maecenas, Alfred Bruyas, who has come to join him in the country around Montpellier and who, as a bourgeois layman, respectfully greets the artist. Is the whole scene not slightly ridiculous? Théodore de Banville, in an ode entitled: «Good Morning, Monsieur Courbet,» gently parodies the Victor Hugo of some poems in «Contemplations», in particular the one in which the flowers of the field, both large and small, bow their heads before the passing poet, murmuring: «It is he, it is the poet.»

«The grass, the bough sagging under the weight of potbellied fruit.
«Sang: "Good Morning, Monsieur Courbet, master painter,
«Good Morning, Monsieur Courbet! How are you feeling?"»

Perhaps the painter's beard points a little too ostentatiously; he is a little too obvious in showing his more flattering profile; even his shadow is better drawn that the shadow of Bruyas. So be it. But this triumph of Courbet in the bright sunlight is in effect the triumph of the artist, the romantic traveler. As André Fermigier accurately points out, *Good Morning, Monsieur Courbet* trembles from an infusion of German «Wanderlust,» the love of travel and its passionate joy, which are so characteristic

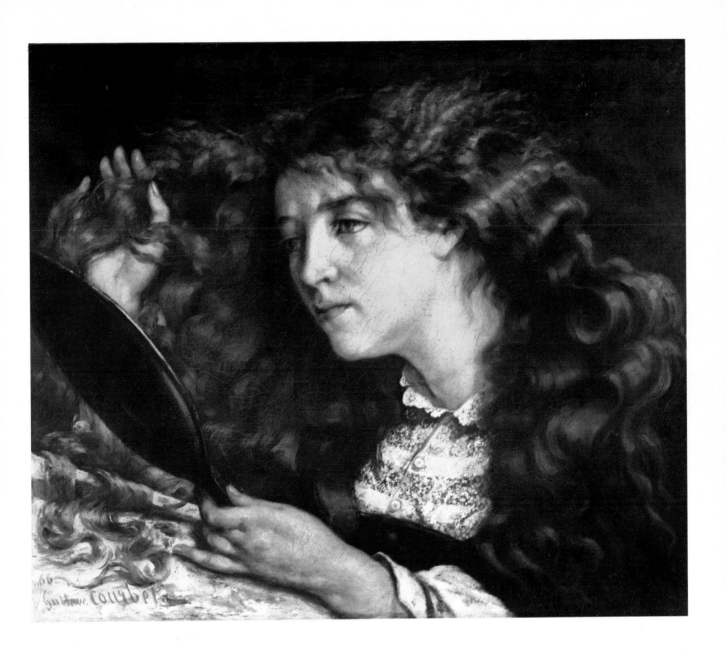

PORTRAIT OF Jo, dated 1866. Oil on canvas, 22″ × 26″ (56 × 66 cm.)
The Metropolitan Museum of Art, New York. Mrs. H.O. Havemeyer Bequest, the H.O. Havemeyer Collection

WOMAN WITH A PARROT, Salon of 1866. Oil on canvas, 51″ × 77″ (130 × 200 cm.)
The Metropolitan Museum of Art, New York. Mrs. H.O. Havemeyer Bequest, the H.O. Havemeyer Collection

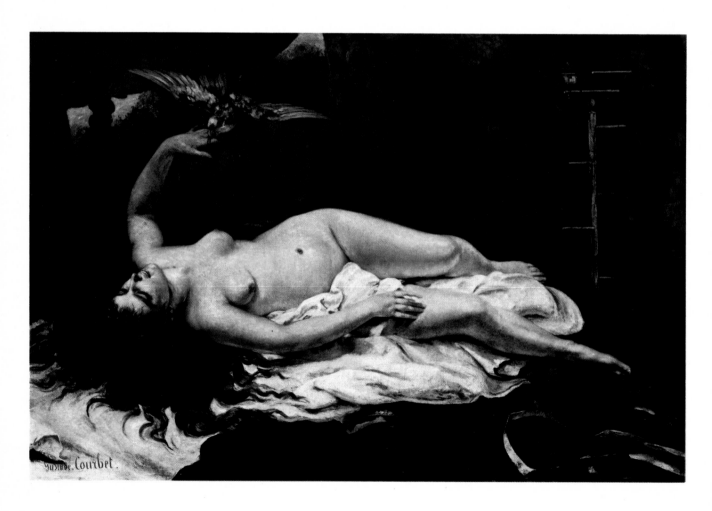

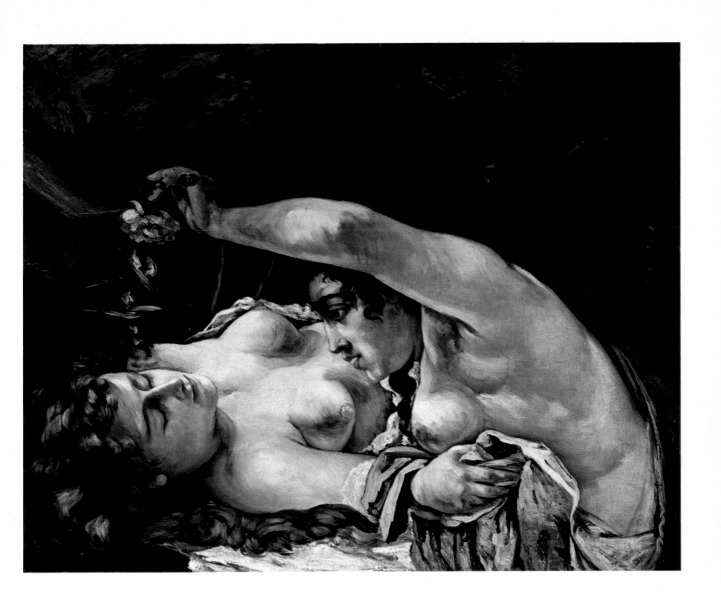

THE AWAKENING (VENUS AND PSYCHÉ), dated 1866
Oil on canvas, $30^5/_{16}''$ × $39^3/_8''$ (77 × 100 cm.) Kunstmuseum, Berne

BEACH AT SAINT-AUBAIN, 1867
Oil on canvas, 21″ × 25″ (53,3 × 63,5 cm.) Collection: Stephen Hahn Gallery, New York

of the soul of a romantic. It has already been compared with certain German paintings: The *Seaside at Palavas* (see p. 36) (1854), with its minuscule cutout of the painter saluting the sea, does indeed remind the viewer of Caspar David Friedrich. In the main, Courbet, with his naïve self-satisfaction, has a freshness and boldness which is not at all typical of the majority of Frenchmen: the too blue blueness of the sky in *The Meeting,* the too small miniature figure before the immense sea are, in their way, Germanisms of French painting. Courbet is a primitive in a way which until that time had beer characteristic only of the Germans.

He was certainly no Rembrandt. In his case a self-portrait did not play the role of a passionate and dramatic questioner of the metamorphoses in a human being; he did not take it on himself to give expression to the conflicts and the dialogue between the forces of life and death which make up a human life and distinguish the various stages in a man's existence. It has been accurately noted that Courbet no longer painted his own portrait during the last tragic years of his exile, when dropsy disfigured him so dreadfully. In *Courbet in Sainte-Pélagie* (see p. 84), apparently executed shortly after his release from prison in December 1871, the ease of the pose, the resignation in the eyes belie any tragic implication. Courbet painted himself as desperate and despairing at the very beginning of his career, during the years 1844–1845; but during the most difficult period of his life, he retained, in this last self-portrait, a tender emotion for the beauty of anything living, even a body already stricken and infinitely weary, even a tree trying to grow in a prison courtyard where the sun somehow managed to shine.

He was not simply indulgent to himself to the exclusion of others. The reader will not be surprised to learn that Courbet painted some of the most moving, most distinguished portraits of the high society of the period. The *Lady of Frankfurt* (see p. 46), done during a stay in Frankfurt in the autumn of 1858 and the winter of 1859, shines with the splendors and also the melancholy of the end of summer. The frontal, frieze-like composition is somewhat reminiscent of the distant mores of neo-classicism. The lady, undoubtedly the wife of a banker, recalls the pose of Madame Récamier in the picture by David, and even the profile of that « middleclass Esther whom Balzac would not have disavowed» (the expression is André Fermigier's), has something of the nobility of an antique statue. The painter visibly had some second thoughts: he obliterated the person in back of the table and shortened the grillwork, thus in effect isolating the principal figure and creating a vacuum to the right. The woman and the dog are looking, waiting for who knows what, who knows whom; the artist has captured them in the fragility of the passing moment. The ice, for according to the indications given by Courbet there is sherbet, is going to melt; the sun will set and winter come. Why not? In this canvas, which could be described as neo-romantic, in which the landscape is one of those which best combine the lyricism and the tawny colors of the Barbizon school, Courbet demonstrates a capacity for emotion and a discernment which are indispensable to a full comprehension of his painting.

One finds the same qualities in a portrait such as the one of *Madame Borreau* (see p. 48), who proved herself to be a hostess as hospitable as she was amiable during the painter's visit to Saintes. The black hat, the costume, the slight backward thrust of the head and the almond eyes gave a recognizably Florentine distinction to the woman who persuaded Courbet, in return for her partiality to the artist or perhaps simply through his generosity, to reestablish her husband's business (women's ready-to-wear and accessories) which was financially shaky. Courbet's supposed vulgarity, like the ugliness of his models, was definitely a myth. At the beginning there was grace. Testifying to this was *The Hammock* of 1844, in which his contemporaries tried a little too hard to read the artist's future. «This is not *Sarah the Bather,*» said Castagnary. «It is a young bourgeoise, shod and clothed as in everyday existence.» And he stressed the conscious impropriety of allowing the dress to reveal yellow boots and white stockings, «something which Ingres would never have dared to do.» Perhaps, although Ingres committed plenty of other indiscretions, but one could equally well turn the proposition around: *The Hammock* is not the last of Courbet's pictures with a romantic bias, heralding the future Realist; it is precisely what Courbet would never cease to be. The drowsy girl of 1844 and the lush woman with a parrot of 1864 indisputably belong to the same universe. The luxuriant red hair of the first are already the tresses of *Portrait of Jo* (see p. 65), the Irish girl Joanna Hiffernan, Whistler's mistress, whom Courbet met in Trouville in 1865–1866 and who posed for him as the model for *The Sleepers.* That Whistler, whose art is so subtle and so distinguished, and Courbet should have been interested in the same model is one more indication of the complexity of the «master painter» of Ornans; in addition, the fact that Joanna was selected to be the incarnation of indolence and lust shows that possibly the sleeping women of 1866 were not so scandalous and evil.

VALLEY OF THE LOUE WITH STORMY SKY, around 1849 (?)
Oil on canvas, 20⁷/₈″ × 25³/₁₆″ (53 × 64 cm.) Museum of Strasbourg

SEASCAPE, 1872
Oil on canvas, 15″ × 18⅛″ (38 × 46 cm.) Museum of Beaux-Arts, Caen

In any case, the feminine type preferred by Courbet, even when rustic and somewhat heavy, had charms and lived up to criteria which would have been acceptable to an academician. The Grecian profile of the sleeping girl in the hammock, even with the trace of a double chin, is not far removed from Ingres. If one compares the various faces painted by Courbet, they have a clear kinship, which cannot be explained solely by the fact that he preferred a certain type of women. The repetition of the same attitudes, as in the case of a Chassériau, represents the pursuit of an ideal attained and then pursued anew. But there is Realism as well in the questioning attentiveness of the models who, knowing accomplices or not, come to take their place in what is assuredly the artist's personal universe. Juliette, his younger sister and his favorite, in the grave and charming portrait of 1844, has a simplicity and elegance which would do credit to a commissioned high-society portrait such as the one of *Nodler the Elder* (see p. 60), done during his stay in Trouville in 1865. Even the posthumous portrait of *Proud'hon and his Family* (see p. 57), a work which was severely criticized and not at all well received, surprises by its « Idealism.» The face, painted from memory, has lost its wrinkles when compared with the photographs of Nadar; the pose, with the play of the hands, has a gracefulness which gainsay the legend of the fierce thinker; the worker's shirt is a way of representing the nobility of antiquity. Courbet wanted to portray Proud'hon in the simplicity if his everyday life «with his children and his wife (Courbet finally deleted her), as was appropriate for a sage of his time and a man of genius.» Tenderness, seriousness, restraint and reserve are perhaps the words best suited to characterize the relations of Courbet with his models when one attempts to build an image which is authentic both in regard to him and to them.

It is this same lyricism which is expressed still more freely in the landscapes and paintings which might be called his «fishing and hunting» works. Here again one must be careful not to interpret this in too restricted a sense: Courbet, yielding to the temptations of accomplishment and success, multiplied such themes, which were calculated to win him public favor. True, but he was sufficiently loyal to his own most profound beliefs to consider them as less important than his great «realistic» compositions. Lastly, looking at the situation chronologically, we see that from the beginning Courbet put on an equal footing and submitted to the Salons works of various and different kinds: landscapes, of course, and animal scenes. Very frequently his large pictures with figures, by the presence of landscapes and familiar animals (as in *Burial at Ornans*), present a synthesis of his predilections and his favorite themes. The analysis of Thoré-Bürger in 1861 is too limited and unjust: «Courbet, who is a wary mountaineer, has not been guilty of the same imprudence as Millet. . . . It is true that people have not broken many stones in Paris, but he understands that public interest is focused on those who cause them to be broken and not at all on those who break them . He has therefore fallen back on deer and foxes, against whom no one would admit having any antipathy.» The citizen of Ornans, the fisherman and the worthy hunter can bear witness to the authenticity of his passion for the hunt; the black dog in the picture of the Petit-Palais, the hunter in *The Artist's Studio,* the farm animals in *Return from the Fair* confirm, if confirmation is necessary, the sympathy for the animal world which is an inherent part of the man Courbet. It is true that it was only starting in 1857 that he sent to the Salon paintings solely of animals. Thus, in the one year of 1857 he exhibited, along with *Young Women on the Banks of the Seine, The Quarry* (Boston) and *The Hind Forced Down in the Snow* (former Douville-Maillefeu collection). Was this in order to make a wider appeal to the public? If so, the experiment was not particularly successful, since those critics who were allergic to Courbet, such as Maxime du Camp, attributed the same weaknesses to all of the pictures exhibited, whatever their subjects. But the favorite argument on Realism as a cult and exploitation of ugliness has to be presented with more nuances. What began to be more clearly apparent as the gamut of his output widened was the individual personality of the painter and not just his role as a stormy petrel.

The *Hunstmen's Picnic* (see p. 47), 1858, as a matter of fact, is a sum of a picture: lunch on the grass, once more posing the problem of putting people in a natural background, which he had attempted the year before with *Young Women on the Banks of the Seine;* a still life with the group of dogs standing watch over the remains of a deer, a hare, pheasants; and finally a landscape, in which, even though the picture was executed in Germany, one finds again evocations of the country near Ornans, such as the cliff. The work is one of the most colorful of Courbet's paintings: orange and gold as *Burial at Ornans* is purple and black. The pure tones of the vermilion vest of the man blowing the horn, the yellow of the trousers, the blue of the water have an altogether extraordinary intensity and resonance. At the same time there are details worthy of Watteau or Desportes in the moiré tones of the huntresses' costumes, the copper of the trees, the roan shades of the animals' coats and feathers. The pleasure of the hunt, the joy of a day when one unwraps and spreads out food for the table and the meat which the hunt has

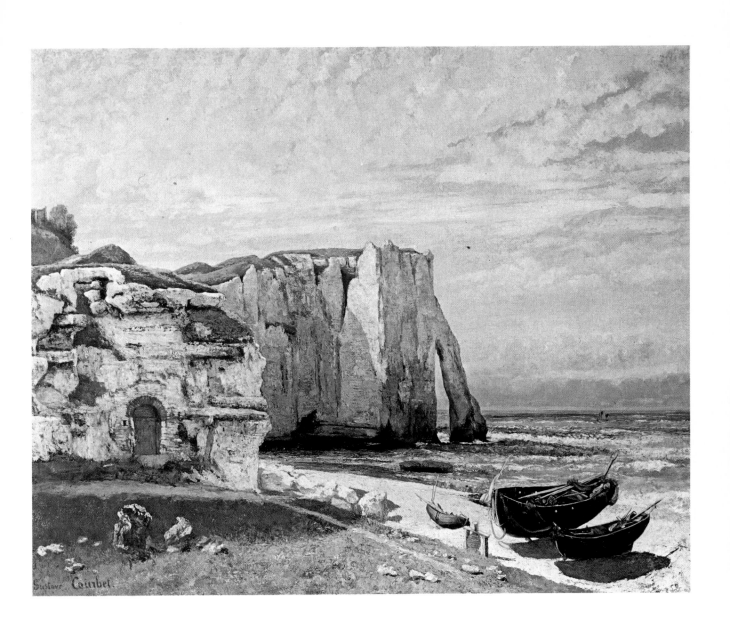

CLIFF AT ETRETAT, AFTER THE STORM, Salon of 1870
Oil on canvas, 51³/₁₆″ × 63³/₄″ (130 × 162 cm.) Louvre Museum, Paris

73

Source of the Lison, before 1848. Drawing, 5^1/$_2$″ × 8^{11}/$_{16}$″ (14 × 22,1 cm.) Louvre Museum, Paris

produced, the warm harmony of nature all burst upon the senses in this sumptuous and happy canvas even as the splendor of the victims is sounded. Perhaps the people and the objects seem to be arranged with a certain stiffness, but the circle which they form resembles a composition by Breughel; they constitute an island where a gala of life and death is being performed. How avoid allusions (one is also reminded of the Venetians and of Bassano in particular with the kneeling cup bearer) in a work which testifies as much to the cultural background of the painter-huntsman as to his personal feelings?

Of five pictures submitted to the Salon of 1861, four are animal pictures. The artist was candid about his intention. «*Fighting Stags* has, in a different sense, as much importance as *Burial,*» Courbet wrote to Francis Wey. «The three pictures ... have no equals, either in traditional art or in modern times. There is not a penny's worth of idealism in them; their value is an exact one, as if it were a mathematical formula,» he added. Thus the work can be explained by its realism or, better yet, by its truthfulness and objectivity. Courbet witnessed similar battles during his stay in Germany in 1858, when he gloried in exploits of the hunt; a twelve-antlered stag which he himself had killed served as a model for the picture. «I am positively certain about the action,» certain about the way he had represented the struggle of the animals. But the impetus and inspiration for this objectivity was primarily the admiration he felt for the power and the passion of the drama. «The combat is as icy as death, the rage profound, the blows terrible.» The great canvas of the Louvre, which has been over-exposed, appeals to us less today than *Stag Taking to the Water of the End of the Run* (Marseilles), which bellows its despair and imminent death in the glimmer of the setting sun; but the mortal combat of the fighters, in the cathedral

74

The Old Castle at Baden-Baden, undated. Graphite, 4″ × 5⅜″ (10 × 13,6 cm.) Louvre Museum, Paris

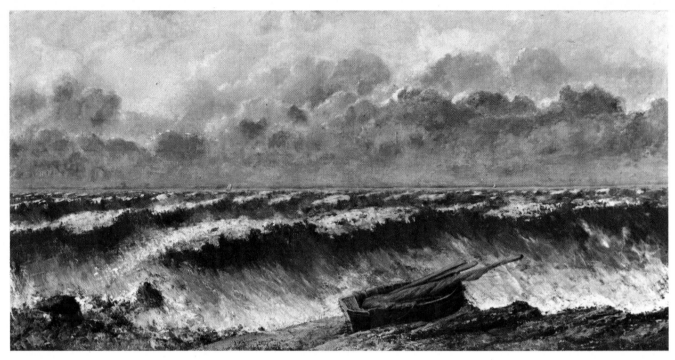

THE WAVES, 1869. Oil on canvas, 29³/₄″ × 59⁵/₈″ (75,5 × 151,5 cm.)
The Philadelphia Museum of Art, the W. P. Wilstach Collection. Given by John G. Johnson, Esq.

of the forest, is pathetic and terrible. The season is springtime and in order to avoid foliage too light or too sparse, Courbet explained that he preferred a landscape of the Jura, «a forest half white wood, half evergreen.» Thus does nature, in its majestic solemnity, participate more completely in the fullness of the action. Whatever Courbet might have claimed, the subject is not a new one. Such themes were dear to the English, to Ward and above all to Landseer; in France, Brascassat and Bodmer specialized in the genre. But Courbet, eliminating all sentimentality, blurring any too apparent purpose, issuing a statement, strikes more forcefully. The lesson of *Burial* is reiterated: the responsibility to portray with simplicity the noble sentiments and deep feelings of man and of nature.

Covert of the Roe-Deer, shown in the 1866 Salon along with the *Woman with a Parrot,* demonstrates with what ease Courbet could go from one end of the scale to the other in the same genre. We no longer have a somber and tragic picture like the *Fighting Stags,* but are refreshed by a restful vision which also presents a contrast to the voluptuous and exotic aura of the *Woman with a Parrot.* They are truly two interior scenes: the parlor and the clearing. Courbet himself suggested the explanation of the paradox in a letter to Cuénot: «This winter I leased some roebucks and made a covert for them; in the center there was a little doe sitting on her haunches and receiving, as if she were in her parlor. Alongside her was her buck. It was charming.» On the one hand, an idyllic scene; the fury of love on the other. The doe and the courtesan represented two aspects of love and the joy of living. But if we try to make does who do not even know that they are being watched, express too much, we risk giving a bad imitation of Proud'hon.... The fact remains that the picture is one of Courbet's most successful paintings. «The elegant animals ... the sun penetrating the foliage ... the transparent water ... the whole harmonious and accurately depicted ensemble, with its overlay of deep feeling, leaves in the mind of the viewer an impression of joy and of lifelike verisimilitude,» Castagnary concluded in a commentary which explains very well the popular success of the picture. The undergrowth, the study of the brook of Plaisir-Fontaine in the Doubs, with its reflections and the nuances of color in the leaves, can hold its own with the best compositions of the great Barbizonians. In its refusal to yield to simplistic treatment or sterile techniques, this canvas is undoubtedly one of the most skillful and polished landscapes of the nineteenth century.

Every season is included in Courbet's repertory. His winter landscapes and hunting scenes form an altogether remarkable part of his total work. In this particular specialty (like Van der Meer in seventeenth century Holland and Cesar Van Loo at the very beginning of the nineteenthe century) Courbet has few rivals. Actually, the difficulty faced by painters of snowy landscapes is how to keep the tones unified and to keep objects in relief so that they do not merge into the background. As was later true of Pissaro, Courbet had such a feeling for the surface of the earth and its various levels that in his art the snow reveals as much as it conceals the unevenness of the ground (a good example is a canvas of 1868, *Snow Scene;* see p. 82). The basic topography of the landscape is visible. At the same time Courbet was fascinated by snow effects and the problem posed by trying to reproduce space and light especially when too homogeneous. On the contrary, «Look at how blue the shadow on the snow is,» Courbet told Castagnary. As a matter of fact, the combination of pure blue and pure white was one of the color balances most cherished by the painter. The harsh blue of Proud'hon's trousers and the white of the shirt, as clear as the sky, of the traveler in *Good Morning, Monsieur Courbet,* all of the intense blues which breach Courbet's canvases are so many evocations and reminders of the color schemes which give vibrancy to Courbet's snowy landscapes. Sometimes they achieve fantastic results, as in *Hunter on Horseback* (see p. 81) of Yale, which was erroneously thought to be a self-portrait of Courbet and which poses silhouettes against the light so that they look supernatural, and focuses on the horse and rider in the foreground, fawn-colored against a blue and white background. *Poachers in the Snow* (see p. 83) (the Rome version is better than the Besançon one) was understandably able to evoke the entire universe and the saga of the Great North. Why not? The two hunters, chosen from the countryside and from among the companions of Ornans, and their dogs, closer to mongrels than to wolves, have a somewhat unnerving presence, isolated in the white universe which they animate with their large blue shadows and their passionate quest.

First of all, Courbet took pains in his landscapes to stress the structure of things. His love for the Jura, where basic structure constantly shows through wherever rock faults permit it, perhaps was slightly more extreme than could normally be expected from someone familiar with the landscapes of his childhood. When he painted other landscapes, such as the valley of the Meuse at Freyr (Lille Museum) or *Cliff at Etretat* (Louvre), he rediscovered those geological formations which lent power to his description of the *Valley of the Loue with Stormy Sky,* (Strasbourg); they are as forcefully present in *Burial* as in

STORMY SEA (THE WAVE), Salon of 1870
Oil on canvas, 46^1/$_{16}$″ × 63^3/$_{16}$ (117 × 160,5 cm.) Louvre Museum, Paris

The Village Maidens. The landscape drawings (see p. 74–75) show very well how Courbet analyses first of all the lie of the land and defines its major structures. In the *Valley of the Loue* (see p. 70), the shadows trailing from the storm clouds accentuate, as if by chance, the depth of the valley, while the cliff temporarily hugs the sun and stands out with increasing whiteness. In this Courbet is closer to Decamps or even the neo-classical landscapists such as Bertin (scandalous thought), Aligny or even Corot in his Italian period than to the Barbizonians, whether they are painting the variegated patterns on the surface of the landscape like Diaz or, like Rousseau, are depicting the depths of a life which surges up naturally from below. In *Gour de Conches* (see p. 52) (Besançon), one might dare to suggest that the water itself becomes a mineral. The eye literally runs into the wall of rocks and the waterfall which occupies almost the whole canvas. The tiny people who are leaning over the bridge are lost, blotted out by the magnificence of a place from which the sky is practically excluded.

Courbet does not build his painting with short strokes as does Decamps, whose painting surface has the consistency of baked bread; for the most part he works with a knife to achieve tones which are frequently pure, without being repetitious; there is not, for example, a foliage which is specifically Courbet's. Thus *Gour de Conches* vibrates with all of the nuances of a light which causes the solids which the artist lets us partially penetrate to shimmer. As a matter of fact, Courbet loved all of the hidden and secret places which only children and passionate hikers are able to discover. *Gorge in a Forest* (see p. 53), executed in 1865, is characteristic of those portrayals of «coverts» in which rocks, trees and water offer to animals or humans who eventually chance upon them inviolate refuges. During a painting session in the open air with Max Claudet, Courbet expained the way he proceeded: «You are undoubtedly surprised that my canvas is black. Without the sun, nature is dark and black. I do as the light does: I illuminate the high projections.» This explains the massive presence of both mineral and vegetable elements of which one is aware in the best of Courbet's landscapes, those in which he did not yield to the demands or the facile ease of an accelerated and semi-industrial production which was characteristic of his later years. The light reveals the great hulks of massive objects and causes them to sparkle, while the underlying darkness, what Courbet would call the blackness, represents a life which is hidden and voiceless. For Courbet, nature was not the merely picturesque or the result of happenstance, but touched by an awareness that objects had a third dimension in which one could breathe more deeply and feel more intensely.

Surely one cannot be astonished that Courbet's seascapes belong to the same universe, which, in one canvas after the other, explains to us the secret of the painter. Possibly too much has been made of Courbet, the man of Ornans, discovering the sea. His visits to Montpellier, in 1854, with the *Seaside at Palavas*, Honfleur (1860), Trouville (1865–1866), Etretat (1868) gave him a good opportunity to prove his virtuosity by forcing him to confront a new problem: how to portray an ever-changing sea and sky, «each one more extraordinary and free than the other,» as he wrote Bruyas in 1866. «It is an amusing exercise,» he added. The meetings with Boudin in 1859 and with Monet, about which Courbet, working at his side, declared: «You are an angel; no one but you truly understands the sky,» certainly contributed to the lightening of his palette. But we should be careful not to categorize him as a pre-Impressionist. Courbet deserves better, and Impressionism is not any more a departure point than it is the place of arrival in the context of which we should invariably judge the painting of the nineteenth, if not the twentieth century. Let us do Courbet, who well understood the pitfalls posed by labels, from Realism to Naturalism, the service of not placing him irremediably in this intermediate position. Like Manet (who faced the same problem in finding a place in art history), he merits neither the honor nor the indignity.

The Waves (see p. 76) (1864) and *Stormy Sea* (see p. 76) of the Louvre (Salon of 1870) depict what is permanent, even though they are concerned with the element of water which is liquid and which is ever in constant motion. The format of the canvases and the three parallel components of shore, waves and sky are, it goes without saying, reminiscent of the long cliffs which are a hallmark of Courbet's landscapes. Yellow, green, blue or green, yellow, blue, the three colors of Courbet, in the order which is appropriate to the seascapes or the landscapes, laid on in broad bands, evoke the geological strata which tell us about the succession of eras and spell out the order of the stages of the world. «Courbet is not a painter of the ephemeral. Everything he sees, he sees from the inside,» was the extremely perceptive comment of André Fermigier. Paradoxically, it is his *Seascapes* that he best reveals his intuitive theory about the universe. The small boats are at rest on the bank. Courbet is not a painter of shipwrecks; for him, accidents and disasters are not what matter. The world has stability. Thus *Cliff at Etretat* (see p. 73) (Salon of 1870), on a theme which was so dear to Monet and his followers, is undoubtedly one of the most definitive images (together with the landscapes of Poussin) ever provided by a painter. The

The Great Stables, Versailles, the Confederates, 1871
Charcoal on gray paper, 26" × 10½" (66 × 26,7 cm.) Louvre Museum, Paris

An Execution, 1871
Charcoal and white chalk, 6½" × 10½" (16,6 × 26,7 cm.) Louvre Museum, Paris

cliffs, which the Impressionists would manage to depict with veritable calligraphic flourishes, are seen «after the storm,» in the moment when they appear newly washed and take on an engaging freshness. In this instance Courbet does not pound his canvas brutally as do certain other artists who have created storm pictures in which the clouds and the waves are heavy with the strength of the unleashed elements. But the delicacy of his golden tones tends to intensify the forcefulness of a landscape in which rocks, sea and boats, what is unmoving as well as that which moves, that which derives from nature as well as what pertains to man, all profit by sharing a moment of eternity. Even a landscape as gracious as *Beach at Saint-Aubain* (see p. 68) (1867), which is idyllic when compared to the odic *Cliff,* with the woman in pink stretched out on the green grass, the two poor children, the reflections of the patches of water on the sand and the vast changing sky, has the virtues gravity and serenity which are characteristic of Courbet.

Courbet's flower pictures express particularly well the joy in contemplating and in painting which elates him. Most of them date from his stay in Saintes in 1862–1863, at the home of the owner of the château de Rochemont, Etienne Baudry, a Republican and an art lover who, like Bruyas, invited the painter to pay him a visit. Courbet had already painted several still lifes; the bouquets of the *Young Women on the Banks of the Seine* and the flowers of *Madame Grégoire* (1850) show Courbet's talents in this sort of painting. In the Saintonge works, flowers and fruit fill almost the total expanse of the canvas, going to the very edge and seeming to tumble out; their richness and exuberance make a convincing statement as to the vitality and profusion of nature's riches. The flowers of the *Flowers in a Basket* (Glasgow) (see p. 51) or of the *Bouquet of Flowers* (see p. 50) squeeze against one another in a disorder and disregard for composition which is a peculiarity of Courbet (in contrast, we need only envisage the admirable convases of the Lyonnais, Saint-Jean, in which the flowers are linked by an arabesque of leaves and stems with surrealist precision). *The Trellis* of Toledo (see p. 49) (1863) is perhaps the most successful example of such canvases: it relates women and flowers with a devastating outpouring of lyricism and tenderness. The young girl, whose dress is even strewn with small flowers, thus becomes in a way a part of the veritable wall of flowers a short distance away which enables the spectator actually to feel the pulse beat of creation. In this vibrant jumble we recognize (in spite of the fact that we spoke a bit earlier of a disregard for composition!) a sort of floral flow which parallels the gesture of the arms of the young woman; thanks to this diagonal movement, the work acquires a dynamism which makes of it a song of praise, a votive offering to a triumphant nature, while the flowers, like a horn of plenty in olden times, spill forth in profusion or rise up to the blue heavens. At the same time there emanates from the young woman a tenderness and deep feeling inspired by the splendor around her which has to be an echo of the emotion which Courbet himself experienced.

The still lifes executed in prison in Sainte-Pélagie in 1871 and in Neuilly in 1872 in the hospital of Doctor Duval have, with reason, been considered the lyrical pictures in which the painter, in his distraught state, best affirmed what remained for him the fundamentals of his art. *Still Life (Bowl of Apples)* (see the back cover), in the Mesdag Museum, explodes with a red which is an affirmation of life, of fury and of hope. Overflowing with the juices of that tragic summer of 1871, they express a basic optimism, a strength, an «élan vital» which, even in the face of disaster, still governs the world. A journalist who visited Courbet in Neuilly described him as being filled with the «desire to walk, to run, to breathe deeply, to sprawl in the grass. He wanted to gather up the earth of the fields by the handfuls ... to wade in the stream, to consume, to devour nature.» *Head of Woman with Flowers* (see p. 85) of Philadelphia is an almost fantastical picture, in that the blooms seem to spring from the very head of the woman reading and to express the explosive quality of the thoughts, the dreams and the impulses which dwell there. One might almost consider a symbolic representation of the world of the mind of Courbet, a prisoner, despondent because of his trial and illness, yet who sees his destiny and the destiny of the universe embodied in the splendor of a bouquet of flowers, nature proving itself stronger than man and the forces of darkness. *The Trout* of Zurich (see p. 90), probably painted in Ornans during his last stay there in 1872–1873 before he was exiled to Switzerland, is also a kind of confession. «It is his own misfortune which he is recounting; it is instinctive nobility of spirit and the fate to which the innocent are doomed which he is evoking for a last time,» wrote André Fermigier. The fierce resistance of the creature who cannot possibly avoid being seized and dragged to his death echoes Courbet's own attitude. In the seagreen world at the bottom of the water, the animal, monstrous in its size and its tension, the same color as the rocks, is in its way an allegory of Courbet's destiny. During his exile, the latter would undoubtedly paint too many landscapes with the assistance of a real studio painting «after the

HUNTER ON HORSEBACK, 1867. Oil on canvas, $46^{13}/_{16}'' \times 38''$ (119,2 × 96,6 cm.)
Yale University Art Gallery. Gift of J. Watson Webb B. A. and Electra Havemeyer

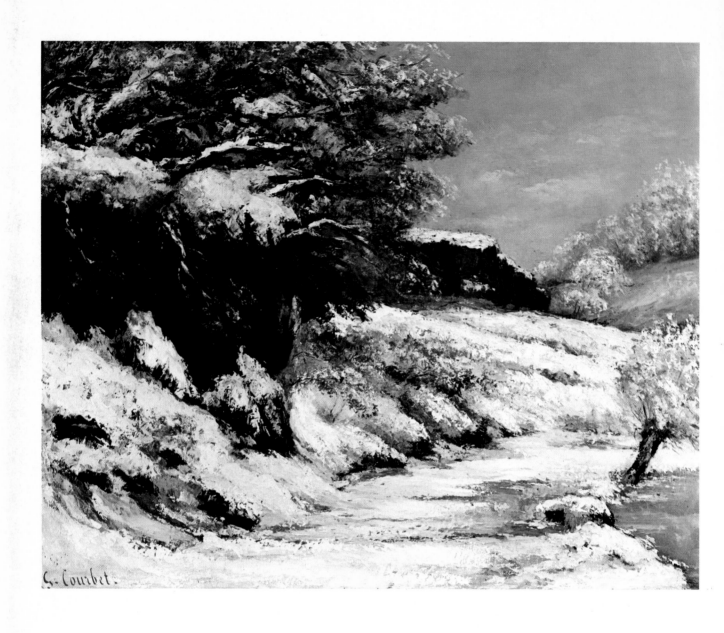

SNOW SCENE, 1868
Oil on canvas, 28⁹/₁₆″ × 36³/₁₆″ (72,5 × 92 cm.) Private collection, Paris

82

POACHERS IN THE SNOW. Replica (?) of the picture dated 1867 of the Galleria d'Arte Moderna, Rome
Oil on canvas, 25⁹/₁₆″ × 32¹/₈″ (65 × 81,5 cm.) Museum of Beaux-Arts, Besançon

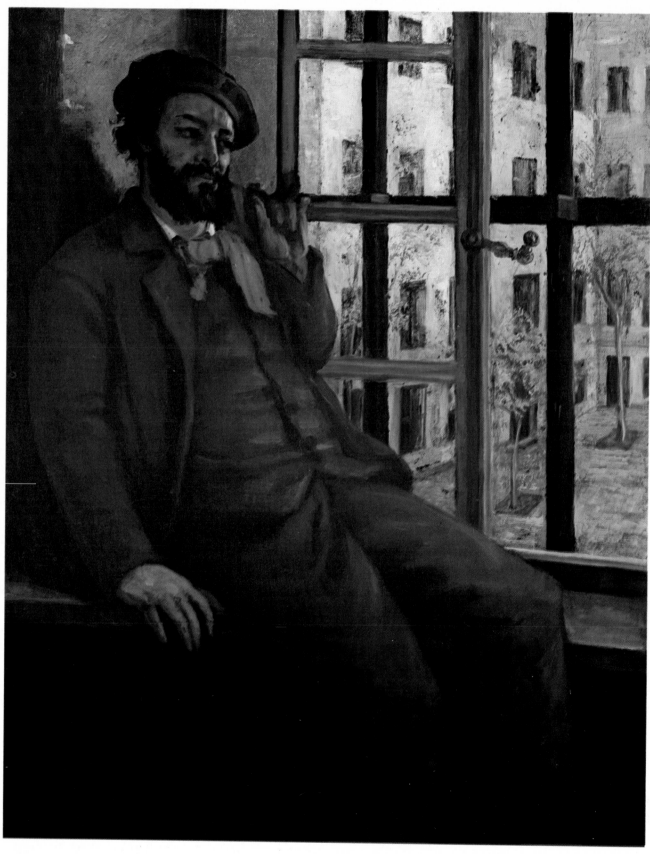

COURBET IN SAINTE-PÉLAGIE, 1871–1872
Oil on canvas, 36³/₁₆″ × 28⁵/₁₆″ (92 × 72 cm.) Municipal Collection, Ornans

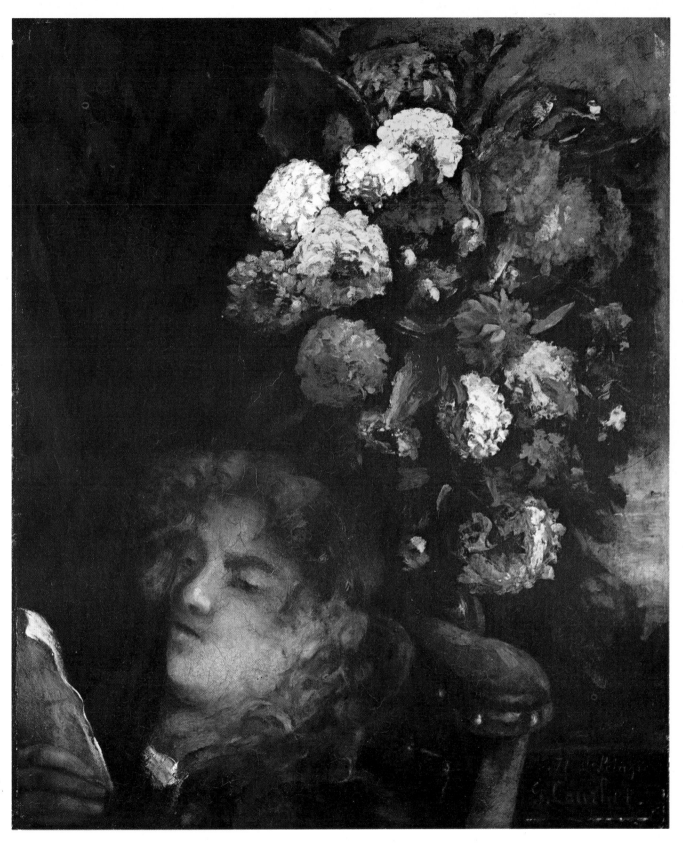

HEAD OF WOMAN WITH FLOWERS, 1871–1872
Oil on canvas, 18¼″ × 21¾″ (46,3 × 55,2 cm.) The Philadelphia Museum of Art, the Louis E. Stern Collection

manner of»: At least *Seascape* of Caen (see p. 71), 1872, a work in which both memory and imagination played a part, with its restrained tones and the subtlety of the cloudy sky, breathes forth air and has a feeling of vastness which explains why free men will always cherish the sea, even if they can only dream about it.

The «Master Painter»

«I have studied ancient art and modern art without prejudice and without being dogmatic about any particular technique or school; I have not tried to imitate one style of painting any more than I have tried to copy another.... No, I simply wanted to extract from a complete knowledge of tradition what could contribute to a reasoned and independent development of my own personal style.» This simple declaration, made in the catalogue of his one-man show of 1855, in spite of its pompousness must be taken seriously. The painter, who practically developed himself single-handedly, whose canvases appear to break with tradition so violently, who announced so loudly that he had escaped from the «grappling hook» of a Phidias or a Raphael, of all s..., as he said, was perhaps one of the most erudite and knowledgeable artist of his era. Certainly he covered up his tracks skillfully; a prime example of this was the radiographic revelation that underneath the *Man with the Leather Belt* (see p. 7) (Salon of 1849) was a copy of *Man with a Glove* by Titian. This clarifies the reference to «Study of the Venetians» which was featured in his brochure; thus was revealed beyond the shadow of a doubt that he paid the tribute of a study and a copy of his work to Titian, whom along with Leonardo da Vinci he had called a «crook.» «If one of that pair should rise from the grave and come to my studio, I would take a knife to him!» It is obvious that this threat by an artistic «enfant terrible» is one that we should be careful not to take seriously. But the important thing, is the now apparent strain of continuity between the study patterned after Titian and the final composition which was superimposed on it; the latter, seemingly indifferent, upside-down, utilized the whites of the shirt of Titian's young man only for the hand. Critics have not wearied of seeking resemblances: whether to Titian, Velasquez or Ribera, none have been able to point out precisely where these lie, as if Courbet had somehow managed to rub out all indications and thus prove that he was truly capable of assimilating completely what he recalled and what he had learnt.

Courbet's pictures have inspired a great deal for imagery and many allusions, but none of them achieve complete credibility, so skillfully does the painter, who can now truly be called a genius, know how to disengage himself. «I have,» he said, «traversed tradition the way a good swimmer crosses a river.» The image is exact. The water supports the swimmer who cuts through it, like Courbet. Attitudes like those of *The Bathers* of Montpellier, which appear inexplicable, inevitably invite comparisons. Thus Corrado Maltese has suggested similarities with certain figures in the Sistine Chapel. Do not the stretched-out arms of the seated woman remind one of those of Adam being chased from the Garden of Eden? Does not the seated Proud'hon evoke the Lorenzo de Medici of the Florentine tomb? The ingenious scholar may well become exasperated, so near does he seem to get, as in the familiar children's game, and so close to finding the exact prototype which he seeks. The amazing composition of the so-called *Preparation of the Bride,* with its experimental perspective, unfailingly brings to mind those banquet scenes of the gods done by the artists of the Flemish Renaissance. Does *The Departure of the Fire Brigade* not elicit a comparison with Rembrandt's *Night Watch,* so closely related are the gesture of the fire Officer and the group coming forward until they seem actually to be pushing outside the picture? All of that is true, but it is still not enough. The explanation lies on the fringes of the mystery. There are forms in Courbet's art, and what might be called keystone principles, which derive from a specific culture and are reinforced by this or that encounter, but which are at bottom the expression of his deepest artistic convictions. Why does *The Winnowers* (see p. 43) (1854) repeat inversely, in the figure of the seated woman, the attitudes of *The Bathers* of Montpellier? Because Courbet's imagination was lacking? That would be too simple an answer. These resurgences reveal and define Courbet's universe, that world of forms which he forces us to accept and reconstructs from canvas to canvas, in a manner that enables us to recognize Courbet every time.

Seeking the sources of Courbet's inspiration is a futile enterprise, since it does not enable one to explain his painting; yet it may help us delve more deeply into the mystery of Courbet, the powerful influence which his creative works still exert, now even more than ever. A century after his death, Courbet

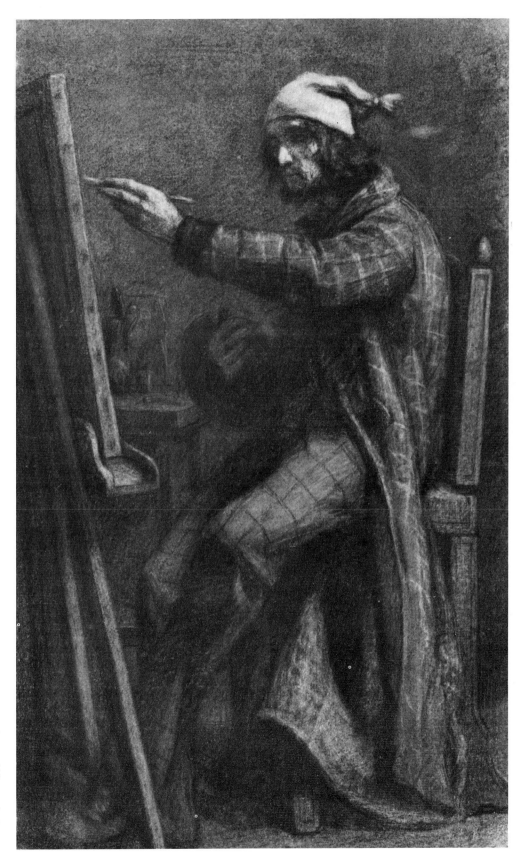

Artist at his Easel,
around 1848–1849
Charcoal on cream
paper, 21¹³/₁₆″ × 13¹/₈″
(55,4 × 33,5 cm.)
The Fogg Art
Museum, Harvard
University.
Greenville
L. Winthrop Bequest

SUNSET ON LAKE GENEVA, 1874
Oil on canvas, 21¹/₄″ × 25⁹/₁₆″ (54 × 65 cm.) Jenisch Museum, Vevey

no longer appears to us, as he did to his contemporaries, to mark a break with tradition. Our view of today readily accepts a face-to-face confrontation between Ingres, Delacroix and Courbet, and Delaroche and Couture as well. In any case, the differences do not arise from the cultural environment in which the works were conceived. In spite of his statements, Courbet was as much of an «academician» as the others, but of a different sort, with the virtues and the naïveté of someone self-taught, or perhaps purely and simply of someone who refused to receive indiscriminately, but insisted on selecting. Contrary to the superficial impression, when he seems to be groping, to miss fire with a perspective, the joint of an arm or a thigh, one feels after reflection that he does this purposely and not through lack of skill. It is in this spirit that one must interpret Courbet's primitivism as illustrated in the portrait of Jean Journet, the disciple of Fourier. As a matter of fact, a man capable from the beginning of his career of intertwining with so much subtlety the curves of a hammock and of the beautiful sleeping woman could never be considered awkward, even cleverly so. The squat cutout of the picnickers of Frankfurt is less indicative of the supposed inability of the painter to place his figures properly against a natural background than of his determination to revive, with apparent naïveté, the spirit of Giorgione. Sometimes Courbet gives the impression that he has failed but, like Goya, still continues to control his resources with a casualness that resembles indifference.

With Courbet, one can never be certain about anything. Here are two examples. «His genius for non-composition,» as André Fermigier so well expressed it, was definitely premeditated. Take the drawing of his original idea for *Burial,* which was to paint a procession. Courbet rejected this obvious solution, which was proposed by Jules Breton, in favor of an unstructured placement of the participants, who are grouped in front of the hole of the grave like a cliff of the living. On the other hand, was Courbet only a painter and not a draftsman? Did he make fun of Raphael and Ingres merely because he had no talent for drawing? Too many of his pictures prove the opposite, beginning with his drawings themselves. Certainly he preferred charcoal: a work such as the *Sleeping Woman,* 1849 (see p. 30), is the drawing of a painter, rich with color and tonal values even within the restrictions imposed by black and white. Similarly, *Self-Portraits* in charcoal, known as *Portrait of the Artist with a Pipe,* (see pp. 14–15), in permanent collections at Harvard and in Hartford, are alive with the Rembrandt-like chiaroscuro effects to which he was partial for his likenesses. In its oddness, *The Artist* (Salon of 1842) takes on a dramatic aspect which demonstrates the power of charcoal to make a vivid impression. But a drawing such as *Lovers in the Country,* a late echo (about 1867) of a famous picture, convincingly testified to his real skill with a pen, to an unexpected zest for calligraphy. The tracing of *Young Women on the Banks of the Seine* in the Jean Matisse collection is reminiscent, in its sureness of touch and its scope, of Puvis de Chavannes and, of course, Matisse. In another category the three notebooks of the Louvre (it is easy to understand why they overwhelmed Aragon) reveal a Courbet capable of capturing dramatic scenes with a pencil and interpreting them with an energy and a sense of pathos which were characteristic of Goya and Daumier (see p. 79). Courbet could have been one of the great political painters of the nineteenth century and have left us images of the French Commune which are altogether missing in French painting. Weariness, illness and the return prior to his death to the constants of his universe may explain the silence which blares forth in the drawings of the Louvre.

* *
*

Jung compares the destiny of men to a sheaf of possibilities which one day must be untied, so that nothing remains but a few branches. Courbet's sheaf was especially thick, and the choices he made were therefore all the more responsive to his true inner needs. Let us detach at random the images to which he particularly applied himself.

Courbet was a man of the soil, but he did not shut out the rest of the world. The countrysides of Montpellier and of Saintes played a large part in his motifs, and the sea broadened the horizon of Ornans. Nevertheless on canvas after canvas he drew the same landscape, in which things were heavy with their true weight, in which earth, sky, rocks and trees expressed primarily the permanence of nature and its secret heart.

Courbet as a man represents stability; but he knew how to paint with such fluidity, such subtlety that he has very few rivals in the nineteenth century. He paints thickly, not at all like Decamps where the painted surface seems to have been baked. He does not treat foliage in a precise systematic

manner as Diaz or Dupré. Curiously enough Courbet's style is peculiar to himself, quite different from the Barbizon School. In his technique the artist remained something of an exception in his period. He was to have imitators but he himself belonged to no group, a Realist without school. Like Hals, like Velasquez his extraordinary painterly ability sets him apart.

Courbet was a Realist, but he always shunned «isms» when he felt too circumscribed by them. He was a social painter, but he had neither the advantage of being a trail blazer (Millet preceded him in the Salon with his portrayals of men working) nor of being a specialist. Horace Vernet, Meissonier, and it is hardly necessary to mention Daumier, teach us more about contemporary life. The man who castigated the society of his time and, with Proud'hon, denounced its vices, was also the man who flattered salacious collectors such as Khalil Bey; he was, as much as Couture, one of the painters who best represented the sensibility of the Second Empire. Plebeian and worldly, distinguished and still a rustic, he painted at once Jean Journet and the fashionable society of sojourns in the country, was as interested in hinds as in poor laborers along the roadside.

Apparently restricted to the motif and an exact translation of reality, his pictures are an unexpected mine for the decoder of hidden messages. Courbet could pass for an esoteric painter, so much do his bouquets of flowers seem to hide symbolic messages and his large compositions to contain political and philosophical lessons, which do not cease to provoke commentaries, rightly or wrongly.

Above all, we should not commit the error of encompassing Courbet within a set formula. Indeed, his genius lies precisely in his capacity to perform without regard to accepted rules, to the established manner of doing things, to customary criteria, in that quality of innocence which made everything he created a new, fresh manifestation of an unspoiled mind. For Courbet, each time Venus rises from the sea, nature is expressing itself anew. With Courbet, we can savor once more the taste of things.

THE TROUT, dated 1871, finished in 1872–1873 (?)
Oil on canvas, 33$^{1}/_{16}$″ × 41$^{15}/_{16}$″ (84 × 106,5 cm.) Kunsthaus, Zurich

BIOGRAPHY

1819 Jean-Désiré-Gustave Courbet was born on June 10 in Ornans (Doubs), a middle-sized town on the banks of the Loue. His father Régis Courbet, « a man of inquiring mind who sought to improve agronomy, » was a well-to-do landowner who tried, with more or less success, to manage his holdings. His mother, Sylvie Oudot, a practical woman, played an important role in his life. His grandfather Oudot, a veteran of 1793, was a republican and a dyed-in-the-wool disciple of Voltaire. Courbet had four sisters: Clarisse, who died in childhood in 1834; Zoé, born in 1824, with whom the painter broke off after the Commune; (wife of the painter Reverdy, she tried to be adjudged his heir and died in confinement in 1905); Zélie (1828–1875), his favorite; and finally Juliette (1831–1915), who would be the recipient of the personal papers and the works of the painter. Courbet had a great deal of affection for his sisters, whom he frequently used as models.

1831 Pupil in the little seminary in Ornans. He apparently was not too good a student. Took drawing lessons with father Beau, who had his pupils work on their subjects in the open air.

1837 Resident student in the royal high school of Besançon, working for his degree in philosophy. His art teacher was Charles-Antoine Flajoulot, director of the School of Beaux-Arts of Besançon, a supporter of David. Liked neither the boarding school nor his classes.

1838–1839 First lithographs. Illustrated the *Poetic Essays* of his friend Max Buchon (1818–1869) with whom he would remain on friendly terms. Undoubtedly Buchon was instrumental in strengthening Courbet's republican and socialist convictions. Religious pictures and the first rather unskillful landscapes. Moved to Paris in the Fall of 1839.

1840 Arrived in Paris, where he dropped out of law shool (his cousin Oudot was a professor there) in order to devote himself to painting. Numerous visits to the Louvre, where he studied the Venetians, the Bolognese, the Spanish, the Dutch, the Flemish of the sixteenth and seventeenth centuries. He also copied the Romantics: Géricault, Schnetz, Robert-Fleury, Delacroix. Was a regular at the studio of Switzerland, where he drew from live models. Pupil of Steuben and Hesse, whose lessons he seems to have taken seriously in spite of his subsequent statements to the contrary. Acquired considerable artistic culture and, although he did not take the regular required courses, received a modern academic education. Steuben and Hesse were classical Romantic painters. Painted landscapes of Jura and Fontainebleau, where he stayed in 1841, portraits of his sisters (Juliette and Zoé), self-portraits and allegorical compositions, *Man Freed from Love by Death,* as well as some Romantic ones: *Walpurgis Night* (1841).

1841 Trip to Le Havre with Urbain Cuénot.

1844 Had painting accepted by the Salon for the first time: *Self-portrait with a Black Dog,* painted in 1842. Executed *Lovers in the Country* (Lyons) and *The Hammock* (Winterthur).

1845 Submitted five pictures, including *Checkers Players* and *Portrait of Juliette Courbet* (Petit-Palais). Only *The Guitar Player* was accepted. Divided his time between Paris and Ornans, as he continued to do subsequently.

1846 Sent eight pictures to the Salon. Only one self-portrait was accepted. Painted *Man with a Pipe* (Montpellier) which would be exhibited in 1850.

1847 Three pictures rejected by the Salon. Trip to Holland, where his painting was appreciated; studied the Dutch painters. Had a son by Virginie Binet, his mistress and his model.

1848 Participated only from a distance in the events of 1848, in spite of his political leanings. Offered seven pictures to the Salon, among them *The Cellist, Portrait of Cuénot, Walpurgis Night,* over which he would paint *The Wrestlers* (Budapest). His studio was at 32 rue Hautefeuille. He saw a great deal of Corot, Bonvin, Champfleury, Schanne and Baudelaire, whom he often met at the Andler Brasserie. Others who frequented it were the painters Decamps, Daumier, François, Chenavard, Nanteuil, the critics and writers Duranty, Jules Vallès, Silvestre, G. Planche and Proud'hon, who was from Franche-Comté. In all, a very varied group which united both those who would become Realists and artists loyal to the Romantic tradition. Realism evolved there as an artistic movement.

1849 Seven canvases were accepted at the Salon. *After Dinner at Ornans* was well received,

bought by the State and sent to Lille. He received a second medal. In the summer, he stayed in Louveciennes at the home of Francis Wey, where he painted with Corot. Spent the fall and winter in Ornans, where he started *The Stone Breakers* and *Burial*.

1850–1851 Nine pictures in the Salon, including *Burial, Peasants of Flagey Returning from the Fair, The Stone Breakers, Portrait of Berlioz* (Louvre), *Portrait of Jean Journet* and a self-portrait: *Man with a Pipe.* Exhibitions in Dijon and Besançon. Stayed in Indre with the socialist poet Pierre Dupont. Exhibited *The Stone Breakers* in Belgium, where it had enormous success. Trip to Germany. Began *The Departure of the Fire Brigade* (Petit-Palais).

1852 Showed *Young Ladies from the Village* (Metropolitan Museum, New York), acquired by Morny, *Portrait of Cuénot* and *Banks of the Loue.* Traveled to Frankfurt-am-Main, where he showed *Burial* and *The Stone Breakers* with considerable success. Did not take any public position when the government was overthrown on December 2, 1851; his friend Max Buchon took refuge in Switzerland. He himself ceased work on the *Fire Brigade.* He was warned to be careful about what he said, but was protected by Morny.

1853 Showed *The Wrestlers* (Budapest), *The Bathers* and *The Sleeping Spinner* (Montpellier). Last two canvases were purchased by Alfred Bruyas, an art collector from Montpellier, a friend of artists and a man mad about painting with whom Courbet had an excellent relationship. Spent the autumn in Ornans.

1854 *The Winnowers* (Nantes). Landscapes of Ornans. Exhibited in Frankfurt. Traveled to Montpellier at the invitation of Bruyas. Painted *The Meeting,* portraits of Bruyas and seascapes. Returned to Ornans via Lyons, Geneva, and Berne, where he saw Buchon. Undertook *The Artist's Studio.* A lunch in December with the Count of Nieuwerkerque, the director of some imperial museums, turned out badly. Courbet turned down his offers.

1855 Year of the International Exposition. The jurors accepted eleven pictures, but rejected *Burial* and *The Artist's Studio.* Furious, Courbet decided to construct his own pavilion at his own expense. The government agreed to give him space on the Avenue Montaigne. He exhibited forty pictures. The financial returns were modest, but from then on Realism was accepted as a fact of life. Traveled in Belgium: Ghent, Brussels, Antwerp, Liège. Was a social success. Returned by way of the Valley of the Rhine.

1856 The debate about Realism continued. Exhibition in London at the Crystal Palace. Silvestre published an article on Courbet; he was admiring but restrained in his appreciation of the painter's evolution. This was also the attitude of Champfleury, who was beginning to review Courbet's works. Went to Belgium.

1857 Six pictures in the Salon, among them *Young Women on the Banks of the Seine* (Petit-Palais) and *The Quarry.* Became acquainted with Castagnary, who substituted the notion of Naturalism for that of Realism. Visited Bruyas in Montpellier. Beginning of a break with Champfleury, who wrote a fairly nasty article on Bruyas.

1858 Another trip to the South of France. A sojourn in Germany in Frankfurt, where he spent the winter. While there, he started the *Stag Taking to the Water* and the *Fighting Stags.* Many superb hunting sessions, drinking bouts and memorable banquets. Painted *The Lady of Frankfurt.*

1859 Returned from Germany in February. Traveled to Le Havre, where he made the acquaintance of Boudin. Seascapes. On October 1st gave a gala of Realism. Frequented the Martyrs café.

1860 Spent the winter in Ornans. Painted *Shipwreck in the Snow.* Saw Buchon in Salins. Sent pictures to various exhibitions in Montpellier, Brussels and Besançon.

1861 Showed five canvases in the Salon, including the *Fighting Stags* (Louvre) and the *Stag Taking to the Water* (Marseilles). Great success; the progress of the painter was judged favorably. Nantes purchased *The Winnowers.* Exhibition in Antwerp. There, Courbet developed his theories on Realism. In Paris, he established a studio which attracted about forty students, of whom Fantin-Latour was the only one eventually to become famous. A reddish steer served as a model. Courbet grew tired of the project very quickly. He experimented with sculpture with *Bullhead Fisherman* (Ornans).

1862 Important visit in Rochemont in Saintonges at the home of a friend of Castagnary, Etienne Baudry, a land owner of a radical bent and an art connoisseur who played the role of a second Bruyas in Courbet's life. Painted scenes of the region with Corot and other artists such as Auguin. A romantic episode with Madame Borreau, the wife of a businessman of Saintes. Numerous portraits, landscapes and flower pictures. He remained there almost six months.

1863 Exhibited in Saintes the works created during his stay there. Painted *Coming back from the Lecture* in the stud farm of Staintes, then in Port-Berteau; it was rejected by the Salon as an « insult to religious piety.» His quarrel with Champfleury, who did not like the picture, grew more bitter. He collaborated with Proud'hon, whose *Principle of Art* would be

published only after his death in 1865. In that same year, 1863, Manet finished *Déjeuner sur l'Herbe* and the Salon of Rejectees, in which Courbet never considered participating, was organized.

1864 *The Awakening* was rejected by the Salon. Juliette accidentally destroyed *The Fountain of Hippocrene*, in which Courbet was portraying contemporary poets; he did nothing further on this composition. Exhibition of his works in Belgium. A sojourn in Franche-Comté; numerous landscapes.

1865 A posthumous portrait of Proud'hon (who died in January) was shown in the Salon. A stay in Trouville, where he meets again Whistler and Monet. Seascapes and society portraits.

1866 A triumph in the Salon with *Covert of the Roe-Deer* (Louvre) and *The Woman with a Parrot* (Metropolitan Museum, New York). He painted *Sleep* (Petit-Palais). Exhibited in Bordeaux and Lille. New disagreements with Nieuwerkerque, who did not purchase *The Woman with a Parrot* as he had promised. Second stay at Deauville with the Comte de Choiseul. Courbet had become a social lion.

1867 He showed only four pictures at the International Exposition but repeated the venture of 1855, which Manet would copy, and had a pavilion erected near the Alma Bridge, where he exhibited a hundred and thirty-two paintings. He had moderate success. Stayed at Saint-Aubain-sur-Mer with his friend Fourquet.

1868 Exhibited in the Salon *Beggar's Alms at Ornans* (Glasgow), which was a failure, and *Roe on the Alert* (Louvre). Exhibitions in Le Havre, Ghent and Besançon. Published extremely anticlerical illustrations for *Parsons on a Spree* and *Death of Jeannot*.

1969 In the Salon, showed *Stag at Bay* (Besançon) and *The Siesta* (Petit-Palais). Stayed in Etretat, where he painted seascapes and landscapes of the coast. Named Chevalier of the Legion of Merit of Saint-Michel by King Louis II of Bavaria, he traveled to Munich, where he was warmly received and was victorious in beer-drinking contests. Copied Rembrandt and Hals. Returned to France by way of Switzerland.

1870 Offered the Salon *Stormy Sea* (Louvre) and *Cliff at Etretat* (Louvre). In June he was awarded the Legion of Honor by the new minister, Emile Ollivier. Courbet refused; he was at the height of his fame and also his notoriety. War was declared in July 1870. The Empire fell at Sedan on August 31. In September, Courbet was elected president of a Commission of Artists responsible for the protection of works of art. In a petition drawn up on September 14, the Commission recommended the destruction of the column in the Place Vendôme. Courbet issued *Two letters to the German army and to German artists* in which he proposed that Alsace and Lorraine be neutral, as a pledge to the security of the United States of Europe. The Commission of Artists was fairly effective in fulfilling its responsibility of protecting works of art.

1871 On January 29, Paris was occupied. The revolutionary Commune acceded to power in March. Courbet supported the new government. President of what was first an Artistic Commission and later a Federation, he was elected a member of the Commune on April 16 and named Beaux-Arts delegate. He resigned in mid-May, protesting against the violence he had observed, and helped save the Thiers collections. The column in the Place Vendôme was demolished, apparently in Courbet's presence but without his direct participation in the action, on May 16. The Commune was overturned on May 28. Courbet was arrested on June 7. Imprisoned in the Conciergerie, then in Versailles, he was condemned by the Council of War to a six-month jail term, first in Sainte-Pélagie, then in the hospital of Doctor Duval in Neuilly, where he was operated on by the famous Nélaton. He painted still lifes and drew.

1872 He was set free in March. His pictures were rejected by the Salon for political reasons. Meissonier in particular was especially harsh in his judgment. Courbet settled in Ornans.

1873 Wanted to participate in the International Exposition in Vienna. Finally exhibited in a private club, with great success. Was once again prosecuted as being responsible for the destruction of the Vendôme column and obligated to contribute to the costs of reparation. His holdings and other assets were confiscated. He went into exile in Switzerland in July and settled in Tour-de-Peiltz.

1874 The trial was resumed in June. In spite of the defense by the noted attorney Lachaud and the depositions of Pyat, on June 26 Courbet was convicted as being guilty of demolishing the column. This decision would be upheld in August 1875, and on July 1, 1877, the money due calculated to be 323,000 francs, to be paid by yearly payments of 10,000 francs.

1875–1876 These years, marked by worries and financial hardship, were a time of frenzied and sometimes overly facile activity. With the help of assistants such as Pata, Cornu and Ordinaire, Courbet, eager to put his personal affairs on a firm footing once more, produced a fantastic amount of work.

1877 Stricken by dropsy, having become enormous, Courbet died, worn out, on December 31 in Tour-de-Peiltz, where he was buried. In 1919 his remains were shipped to France, to Ornans.

BIBLIOGRAPHY
GENERAL WORKS ON THE ARTIST

There is an immense amount of literature on Courbet. We shall list just a few of the books and articles which have seemed to us particularly stimulating and which are fairly accessible.

Biographie Studies

The basic biography, no longer new but still indispensable, is Georges Riat's *Gustave Courbet, Peintre,* Paris, 1906. Among the most intelligent and innovative of recent works is the volume by André Fermigier, *Courbet,* Geneva, 1971. The successive biographies of Charles Léger, Paris, 1925, 1929, 1934, stress the new insights which developed in the period between the two wars. The monographs done by Théodore Duret, 1918, Giorgio de Chirico, 1925, Pierre Mac Orlan, 1951 and above all Aragon, *L'Exemple de Courbet,* 1951, which reproduces the notebooks of drawings done in the Louvre, are of value primarily because of the personalities and reactions of the authors. *Gustave Courbet, Peintre de l'Art Vivant,* by Robert Fernier, Paris, 1969 provides a fascinating comparative photographic report on the various sites in Ornans.
Courbet's stay in Saintes was the subject of an exhaustive study by Roger Bonniot: *Gustave Courbet en Saintonge,* Paris, 1973. The Bulletins of the Society « Les Amis de Courbet » (The Friends of Courbet) since 1947 have reprinted many informative articles. For critiques of the episode of the Vendôme column, readers may consult Castagnary, *Gustave Courbet et la Colonne Vendôme. Plaidoyer pour un ami mort,* 1883 and Maurice Choury, *Bonjour, Monsieur Courbet,* Paris, 1969.

Manuscripts

The Cabinet d'Estampes in the Bibliothèque Nationale is a repository for invaluable source material, the *Archives de la Famille Courbet, Prost et Castagnary,* documents collected by Moreau-Nélaton and Riat.

Printed works

The work by Pierre Courthion, *Courbet raconté par lui-même et par ses amis,* 2 vols. Geneva, 1948, which contains selected contemporary opinions on Courbet and his writings, is as practical as it is indispensable, It provides, for the reader without much time for research, access to the writings of Silvestre, Castagnary, Ideville, Gros-Kost, Troubat, etc., to whom we are indebted for recollections and statements based on first-hand experience. Several letters of Courbet have been included in Pierre Borel, *Le Roman de Gustave Courbet,* Paris, 1922 and *Lettres de Gustave Courbet à Bruyas,* Geneva, 1951.

Catalogue

Robert Fernier, who died in June 1977, undertook the colossal and hazardous task of preparing a complete catalogue of Courbet's works. The first volume was finished at the time of his death.

Critics

For information on Champfleury, one can use the collection edited by Geneviève and Jean Lacambre: *Champfleury, le Réalisme,* Paris, 1973, and on Zola, the volume of Jean-Paul Bouillon: *Le Bon Combat de Courbet aux Impressionistes,* Paris, 1974. The critical apparatus is impressive. *Salons* by Castagnary, 2 vols., Paris, 1892, the works of Thoré-Bürger, Paris, 1870, as well as the volume by Proud'hon, *Du Principe de l'Art et de sa Destination Sociale, Paris,* 1815 were allowed to go out of print and have not been reprinted. One can examine Courbet's caricatures thanks to the book by Charles Léger, *Courbet selon les Caricatures et les Images,* Paris, 1920, which is invaluable from an iconographical point of view. *The Studio* has inspired veritable monographs. The book of René Huyghe, Germain Bazin and Hélène Adhémar, *Courbet, l'Atelier,* Paris, 1944 should be supplemented by the work of Benedict Nicolson, *The Studio of a Painter,* London, and above all by Hélène Toussaint's article in the catalogue of the 1977 exhibition, which upsets all the conclusions of conventional wisdom by suggesting new means of identification and an explanation of Courbet's art through Freemasonry.

Anglo-Saxon critics have been particularly concerned with trying to evoke the social, political, literary and pictorial milieu of the period and placing Courbet in the context of his time. The books of Linda Nochlin, *Invention of the Avant-Garde,* 1830–1880, New York, 1968, Jack Lindsay, *Gustave Courbet, his Life and Art,* Bath, 1973, and especially the book by T. J. Clark, *Image of the People, Gustave Courbet and the 1848 Revolution,* cause the history of 1848, with its republican politicians and its taste for Realism, to live again.

The articles of Meyer Schapiro, *Courbet and the Popular Imagery, An Essay on Realism and Naïveté, Journal of the Warburg Institute,* 1941, of Linda Nochlin, *Innovation and Tradition in Courbet's Burial at Ornans, Essays in Honor of Walter Friedländer,*

New York 1965, and by the same author: *G. Courbet's Meeting, A Portrait of the Artist as Wandering Jew, The Art Bulletin,* 1967, the researched work of Corrado Maltese, *Bulletin de la Société de l'Histoire de l'Art Français,* 1977, of Alan Bowness, *Courbet's Early Subject Matter;* Manchester, 1969, *Courbet's Atelier du Peintre,* Newcastle-upon-Tyne, 1972, the photographic dossiers issued by the experimental laboratory of the Museums of France, *Annales,* 1973, enable one to get a taste of the extraordinary variety of popular and scholarly documents on Courbet and to savor their stylistic differences.

Exhibitions

Next to the exhibition of 1882 at the Ecole des Beaux-Arts, the most important show prior to 1940 was the 1929 exhibition at the Petit-Palais. Among the recent exhibitions which have put numerous pictures on display anew and altered opinion concerning them: 1949, Paris, Alfred Daber; 1955, Paris, Petit-Palais; 1960, Boston; undoubtedly the most important show before the one of 1977. 1966, Paris, Claude Aubry Gallery, *Courbet dans les Collections Françaises;* 1969–1970, Rome, Villa Medici; a remarkable catalogue. 1973, Museum of the Louvre, *Autoportraits de Courbet;* 1977, Paris, Grand-Palais; 1978, London, Royal Academy; the catalogue was done by Hélène Toussaint. Undoubtedly, for a long time to come the obligatory point of departure for any serious student of Courbet must be the biography by Marie-Thérèse de Forges. The novelty of her views and the points she makes, insofar as it inspires spirited discussion, act as a powerful stimulant.

PHOTOGRAPHS

E. Irving Blomstrann, New Britain, Conn. – Bulloz, Paris – Eric Ed. Guignard, Vevey – Gérard Howald, Berne – Franz Jupp, Strasbourg – Lauros-Giraudon, Paris – Studio Meusy, Besançon – Clichés Musées Nationaux, Paris – Otto Nelson, New York – Claude O'Sughrue, Montpellier – Joseph Szaszfai, New Haven, Conn. – O. Vaerig, Oslo.

We wish to thank the owners of the pictures by Gustave Courbet which are reproduced in this work

MUSEUMS

Wallraf-Richartz Museum and Ludwig Museum, Cologne – Museum of Beaux-Arts of Besançon – Museum of Beaux-Arts of Caen – Museum of Art and History of Lille – Musée Fabre, Montpellier – Museum of Beaux-Arts, Nantes – City Collection, Ornans – Louvre Museum, Paris – Museum of the Petit-Palais, Paris – Museum of Strasbourg – National Gallery, Oslo – Kunstmuseum, Basel – Kunstmuseum, Berne – Jenisch Museum, Vevey – Oskar Reinhart «Am Römerholz,» Winterthur – Kunsthaus, Zurich – Glasgow Art Gallery – City Art Gallery, Leeds – Cleveland Museum of Art – Wadsworth Atheneum, Hartford, Conn. – Fogg Art Museum, Harvard University – Metropolitan Museum of Art, New York – Smith College of Art, Northampton, Mass. – Philadelphia Museum of Art – Toledo Museum of Art – Yale University Art Gallery.

GALLERIES

Acquavella Gallery, New York – Stephen Hahn, New York.

PRIVATE COLLECTIONS

Mr. and Mrs. James W. Alsdorf, Chicago.

ILLUSTRATIONS

After-Dinner at Ornans 20

Artist at his Easel . 87

Artist's Studio (The) 34–35

Awakening (The) 67

Bathers (The) . 33

Beach at Saint-Aubain 68

Beggar's Alms at Ornans 56

Burial at Ornans 21–22–23

Cliff at Etretat . 73

Coming back from the Lecture 59

Courbet in Sainte-Pélagie 84

Covert of the Roe-Deer 54

Departure of the Fire Brigade (The) 26–27

Desperate One (The) 17

Execution (An) . 79

Fighting Stags . 55

Flowers . 50

Flowers in a Basket 51

Gorge in a Forest 53

Great Stables, Versailles, the Confederates . . 79

Hammock (The) . 9

Head of Woman with Flowers 85

Hunter on Horseback 81

Huntsmen's Picnic 47

Lady of Frankfurt 46

Lovers in the Country (The) 11

Madame Borreau 48

Man with the Leather Belt 7

Meeting (The) . 37

Old Castle at Baden-Baden 75

Poachers in the Snow 83

Portrait of the Artist with a Pipe 15

Portrait of Jo . 65

Portrait of Juliette Courbet 12

Portrait of Monsieur Nodler 60

Preparation of the Dead Maiden 42

Proud'hon and his Family 57

Seascape . 71

Seaside at Palavas 36

Self-Portrait . 14

Self-Portrait with Black Dog 5

Siesta . 29

Sleeping Spinner (The) 25

Sleeping Woman 30

Snow Scene . 82

Source of the Lison 74

Stone Breakers . 39

Stormy Sea . 76

Sunset on Lake Geneva 88

Trellis (The) . 49

Trout (The) . 90

Valley of the Lauterbrunn 63

Valley of the Loue 70

Village Maidens (The) 28

Waterfall at Conches 52

Waves (The) . 76

Winnowers (The) 43

Woman with a Parrot 66

Woman in the Waves 40

Wounded Man 6, 10

Wrestlers (The) . 32

Young Women on the Banks of the Seine . 44–45